# Richard Slee

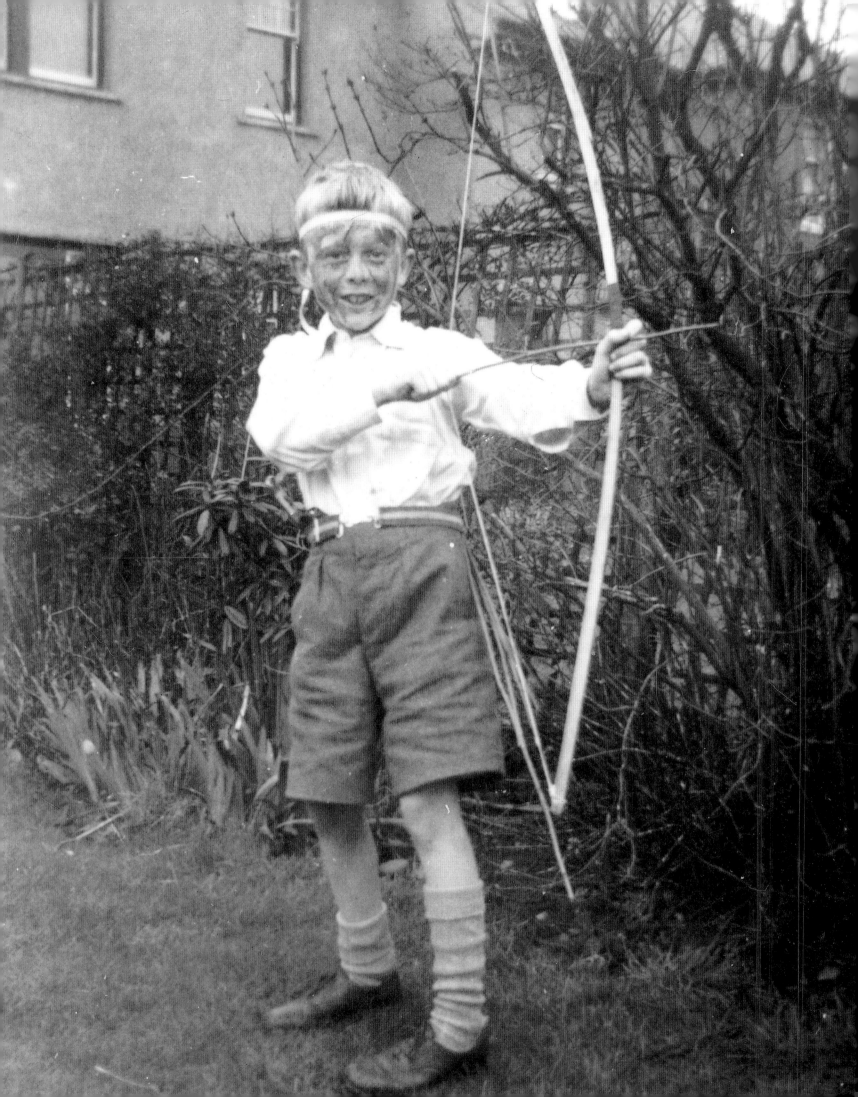

The Potteries Museum & Art Gallery, Stoke-on-Trent
in association with Lund Humphries

# Richard Slee

Garth Clark
and Cathy Courtney

The Potteries Museum & Art Gallery
Bethesda Street, Hanley
Stoke-on-Trent ST1 3DW
www.stoke.gov.uk/museums

in association with

Lund Humphries
Gower House
Croft Road
Aldershot
Hampshire GU11 3HR

and

Suite 420
101 Cherry Street
Burlington
VT 05401
USA

www.lundhumphries.com

Lund Humphries is part of Ashgate Publishing

British Library Cataloguing-in-Publication Data
A catalogue record for this book is available from the British Library

ISBN 0 85331 884 0

Library of Congress Control Number: 2003104036

*Richard Slee* © The Potteries Museum & Art Gallery 2003
Text © 2003 the authors
All photographs © Richard Slee unless otherwise stated

Designed by Chrissie Charlton & Company
Project Management by Simon Perry
Typeset by Tom Knott
Printed in Singapore under the supervision of MRM Graphics Ltd

frontispiece
1 Richard Slee as a child
1953

# Contents

Show5 project initiated by
the Crafts Council

Funded by

Participating galleries

Birmingham Museums
  & Art Gallery
The City Gallery, Leicester
Crafts Council, London
Manchester Art Gallery
The Potteries Museum
  & Art Gallery, Stoke-on-Trent

THE CITY GALLERY

# Foreword

This book is one of a series of five developed as part of the *Show5* partnership initiated by the Crafts Council. *Show5* is the largest collaborative venture between five British museums and galleries, each focusing on the work of one of five leading makers who have helped define the territory of contemporary craft. The aim of this project is to celebrate the impressive achievements of these ground-breaking individuals who have both shaped and influenced the modern craft movement during the last 30 years. Their creative developments and innovative voices are documented and promoted here for an international readership.

The five artists invited to participate work with a wide range of craft media: Carol McNicoll's highly patterned and darkly humorous ceramics; Jim Partridge's pioneering woodwork, which ranges from vessels and furniture to large-scale architectural works; Michael Rowe's complex geometric metalwork; Richard Slee's 'Neo-Pop' ceramics; and Ann Sutton's innovative and experimental woven textiles.

What they do have in common is a desire to expand the boundaries of their craft and take it beyond the conventional and expected. They may, like Slee, McNicoll and Rowe, use traditional techniques to create a style of work that is instantly recognisable. Or, they may employ unusual techniques, like Partridge who uses blowtorches and chainsaws to sculpt his material or Sutton who utilises computer-driven looms.

*Show5* is sincerely grateful to the National Touring Programme (Arts Council of England) and Esmée Fairbairn Foundation who have generously supported this creative project. Our thanks also go to Lund Humphries and the writers who had the vision to see the potential for this craft series and with whom we are very pleased to be working. *Show5* would like to thank the five partner galleries, the five artists, the lenders and all those who have contributed their time, ideas and support. A special mention to Kate Brindley and John Williams, without whose energy, commitment and support the project would not have been possible.

**Louise Taylor**
Director, Crafts Council

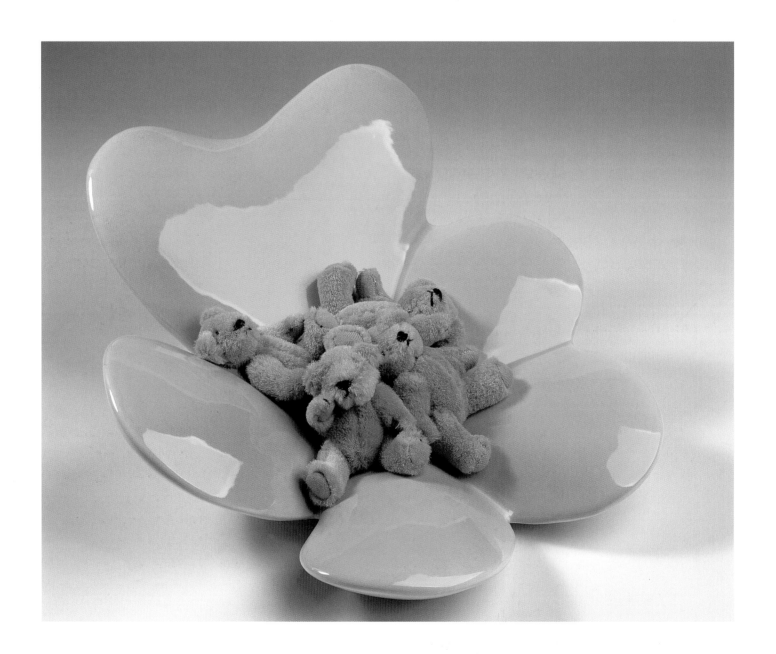

# Introduction

2 **Bears** 1999
With additions
W. 34 cm: 13.5 in
Collection: the Artist
Photograph: Zul

Richard Slee is one of the most original and significant figures working in contemporary ceramics. During a career of over 30 years, he has gained an international reputation and his work is collected and exhibited worldwide from Europe to America, Japan and Korea. He has taught at many of the leading British art schools. In 2001, Richard Slee was awarded the prestigious Jerwood Applied Arts Prize for Ceramics for his innovative vision and influence.

Subversive, intriguing, humorous and thought-provoking, Richard Slee's work questions conventional expectations of ceramics and the traditional status of the potter. His pieces are a celebration of the domestic and familiar, although his dishes, jugs and vases are decorative and ornamental rather than functional. Richard Slee draws upon an extensive knowledge of ceramic history and techniques. He has mixed an eclectic range of influences from delftware tiles to early cartoons and computer graphics. Historical references are combined with contemporary; high art with popular culture. His beautifully handcrafted, brightly coloured glossy ceramics are highly distinctive in style. Visually engaging, Richard Slee's work incorporates underlying meanings exploring autobiographical and social and political themes. Diverse subject matter has included the decline of socialism, the aids crisis and British xenophobia.

This book is the most substantial publication of Richard Slee's work to date. Along with the accompanying retrospective exhibition, it charts his development from the early pop-influenced works of the 1970s to the more recent sculpture pieces and those incorporating found objects. All the different series are presented from Victoriana and cornucopias to toby jugs as well as flowers, plants and landscapes. The viewer can only wonder at the full range and energy of Richard Slee's imagination and inventiveness and look forward to new boundaries being challenged by the craft world's 'resident alien'.

**Sarah McHugh**
Collections Development Officer
The Potteries Museum & Art Gallery, Stoke-on-Trent

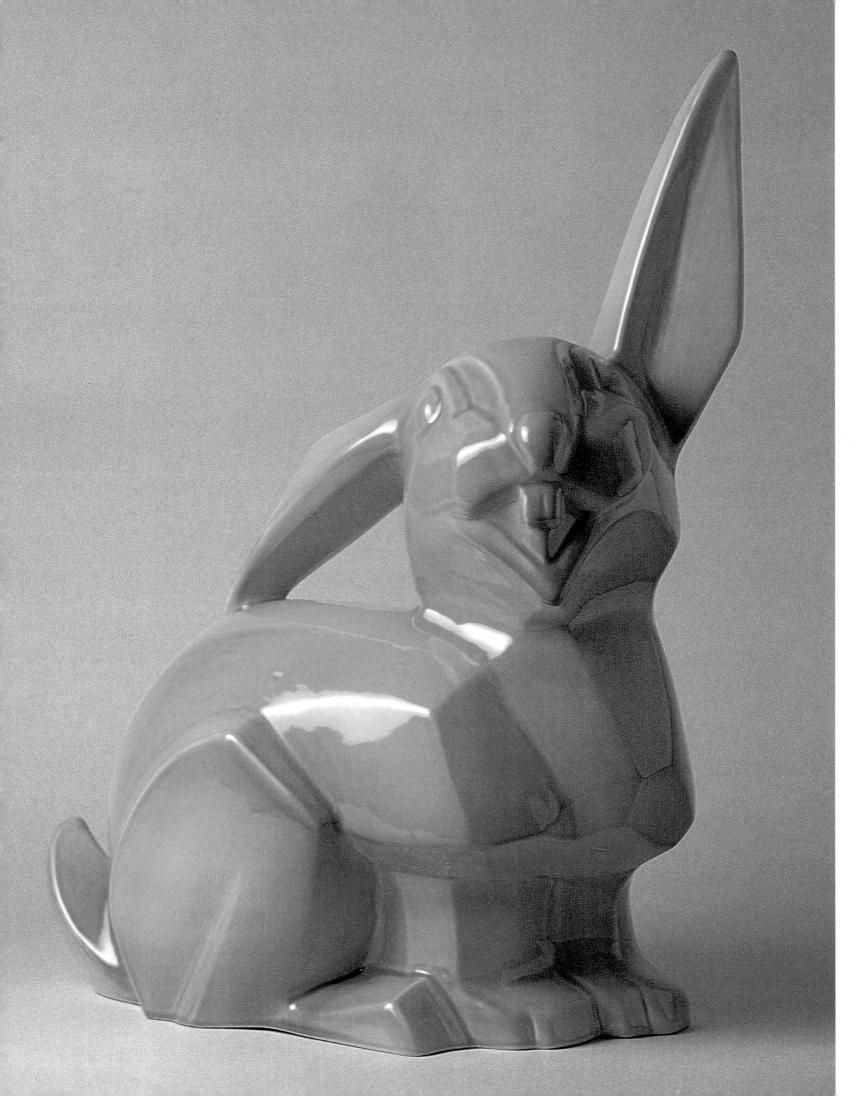

# Richard Slee
## Cathy Courtney

3 **Appropriated Rabbit** 2002
H. 54 cm; 21.25 in
Private collection
Photograph: Philip Sayer

'Can you find the bird of paradise?' A boy, smaller than the vase he stands beside, searches a sea of cobalt-blue swirls, edging gradually round the china shape as he does so. When he discovers the bird he finds it a little frightening but is fascinated by what seems to him a glimpse of the exotic, a world beyond the confines of Carlisle, the town where he is growing up. Other objects 'high on the gazing list'[1] include his grandmother's toby jugs, kept on a shelf out of reach, and the willow pattern plates she uses as the setting for telling stories. Three of the boy's grandparents are from Cumberland stock, his maternal grandfather is from the East End of London. The boy learns early about differences between people; his paternal grandparents are Plymouth Brethren and disapprove of his mother's Methodist family. When, wearing his best clothes, he visits his grandparents' dark terraced house on Sundays, he is given Bible tracts illustrated with what he later realises are lithographs. Although these visits are formal (he never once goes upstairs in this house), he is permitted to look at a collection of silk cigarette cards and at two sets of bound magazines which have, somehow, migrated to Carlisle from America. The cigarette cards are the main source of colour in the room and the magazines contain potent photographs of freakish incidents; years later he still recalls an image of a straw driven through a plank by the force of a tornado.

For Richard Slee, born in 1946 and growing up in the inflexibility of post-war Britain, intimations of another world demanded attention. Images did not routinely dissolve on screens (his parents were late in getting a television, domestic computers were unknown); the Gothic pen-and-ink illustrations of childhood books, Ronald Searle cartoons and comic strips could be pored over and revisited. Toys were limited but Slee, who spent quite a lot of his childhood alone, was adept at transforming a cricket stump into a tommy-gun using a couple of nails. Objects belonging to his parents were worthy of examination too – a heavy bronze ornament that once held a clock face, kept for its scene depicting a Dutch girl pouring water into a beaker, a plastic tortoiseshell stationery set, silver trophies his grandfather had won as a runner and tankards from his father's golf victories. Ashtrays were brass and hung over sofa arms on strips of fringed leather.

'Everything is domestic that I'm concerned about. It's about interior space.' This comment, made in 2002 about his work, was also true of Slee as a child. Uneasy with the scale of the world outside, he found a visit to the local football stadium 'spatially disturbing', with its ranks of men turned into a roaring human solid because everyone was dressed alike in fawn raincoats and flat hats. Nor did he feel linked to the astonishingly muscular players who thumped into close-up every now and then. Team sport would never be of interest. The landscape of the Lake District did not strike a chord either – 'Too beautiful, I'm suspicious of beauty.' Although he joined in family walks with his parents and sister (Ann, four years his senior), he preferred W. Heaton Cooper's (1903-95) print of *Blackmoss Pot* that hung in the living room to the actual waterfall. As an adolescent, though, he became a rock climber for a few years, relating to the 'extreme, craggy towers and secretive spaces', engaged in a competition against himself – an experience that has perhaps now transferred to the ceramic studio – and he relished the vocabulary of climbing with its classifications for different holds and manoeuvres.

If the outdoors held less appeal, the interior that yielded the most treasure belonged to two spinsters, Madge (a relation) and Agnes (an aunt by name). Their Carlisle living room, 'like a nomad's tent', was entered from the street door, past a heavy velvet curtain. (Perhaps this was the beginning of the appeal for living with the blinds partially drawn, which Slee does whenever he lives alone, starting when he moved to a London bedsit in 1965, not because of the view outside or any sense of being observed, but more from a wish to concentrate on the inside space.) Aunt Agnes had souvenirs from the South Sea islands – a shiny, hollow turtle shell, an octagonal bowl decorated with blue and white galleons. Given her stamp collection, Slee was absorbed by the strange images of Third Reich stamps with their Nazis on motorbikes, and by the cleanliness of an Edward VIII stamp designed with minimum extraneous detail. Slee is naturally methodical. Through ownership of the stamp collection he learned to handwrite and print with precision, wanting each stamp to look exact within its ruled square.

4 **Nautilus fabric** Mid-1950s
Desgner Mary Warren, for Heals
Collection: Francesca Galloway
Gallery, London
Photograph: Matt Pia

It was at the aunts' home that he encountered the mysterious bird of paradise. Today the vase stands beside his bed in his Brighton home. Although the object, probably a Japanese import made between 1880 and 1890 for the British market, is not one he would want to make himself, he admires the skills it displays; the faultless fluidity of the cobalt line (one of the most difficult pigments to use) and the technical feat of throwing an object on this scale. The fact that the vase has been in Slee's world for so long indicates the steadiness of his background. In 2002, his parents still lived in the house they bought in the year of his birth; asked to check on some of the objects that surrounded his growing up, Slee could do so because they were still there. Carlisle itself was as unturbulent as his private life. A survey carried out when he was a teenager confirmed the town as one of the most stable populations in the country. There were virtually no foreigners – he remembers how people stopped in the street to stare at a Chinese family who arrived to open a restaurant – and he can still recall his surprise when first seeing a black man, encountered in a lift during a rare family visit to London. The inventor, Rowland Emett (1906–90), clad in green corduroy, suede shoes and rouge, left as great an impression as his eccentric clock when he toured to Carlisle in the early 1950s.

Even this environment was not immune from outside influences. On the domestic front, catalysts came in the form of presents from Ann's Finnish penfriend, a delicate silver leaf made by Tapio Wirkkala (1915–85), a blown blue glass vase by Timo Sarpaneva (b.1926) – identical to one in the collection at Camberwell College of Arts where Slee now teaches – and modern glassware of a quality rarely found in Carlisle. Gradually, Slee's parents purchased Arabia dinnerware and replaced his bedroom curtains with 'Nautilus' fabric. By the 1960s the family home began to alter more rapidly. The traditional fireplace was repositioned to be off-centre in the wall, surrounded by local slate. A Danish sofa appeared. Midwinter's *Spanish Garden* became the daily china service, itself somewhat dislodged by the arrival of a television set and oval TV-dinner plates recessed for cups. Asked if these were used for real or tongue-in-cheek, Slee is not quite sure, but he knows that he was alert to the household changes and enjoyed them. His bedroom began to reflect the times, one

Rowland Emett

5 'You see they used to be in
industry during the war.' 1946
Illustration
Collection: Punch Limited
Photograph: Punch Picture Library Limited

14

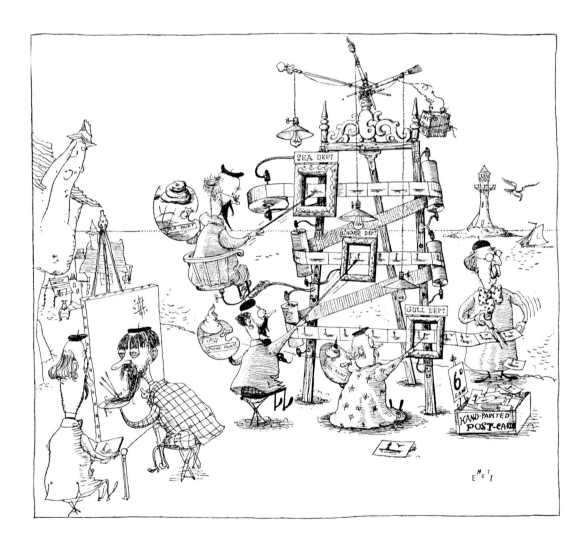

6 **Vera** 1972
Collage
Collection: the Artist

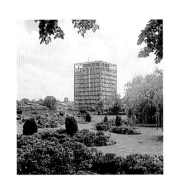

7  Carlisle Civic Centre
Photograph: E. A. Bowness

wall virtually papered with torn out pages from the newly published *Sunday Times Colour Supplement*, Stuart Davis' *Lucky Strike* and Peter Blake's *Babe Rainbow* acting as sirens from a society as yet out of reach. The fashion-conscious youth took in his grey school trousers to make a pair of drainpipes, surreptitiously changing in the garden shed so as not to be discovered.

On a broader scale, Slee remembers two public buildings being significant whilst he was growing up. One was Coventry Cathedral, to which he was taken soon after the post-war restoration work was completed, and the other was Carlisle's new Civic Centre, the first high-rise building in the town and the cause of local controversy. Although he now makes a more sophisticated appraisal of the Centre, at the time Slee found the building exciting. It may have held particular significance for him because it was where his father worked as a municipal accountant, but it is more likely that he responded because he was already interested in architecture through a book on Le Corbusier which he had found in the public library, so much so that he decided he wanted to become an architect himself. Unfortunately, in the pre-internet world, there was no one to advise on how this might be achieved.

Slee was a shy child, and his schooling had got off to a bad start causing him to fail the eleven-plus. Things improved when he reached the newly built Harraby Secondary Modern, where he achieved a clutch of O-levels and became one of three pupils constituting the school's first sixth form, studying Engineering Drawing and Geography. As well as the formal teaching, he began to be influenced by the socialist sympathies shared by most of the staff, and by this time was reading Camus and toying with the notion of the existentialist outsider. He was not so much an outsider, though, as to be unmoved by the Beatles, and admits to feeling 'part of something'. In time, he began to make trips with friends to Manchester and Newcastle and, occasionally, London, where they would buy satin shirts with high collars, bell-bottomed jeans and Madras jackets in Carnaby Street and hang around in Soho afterwards.

London was also the scene for the briefest interview in Slee's life, at the Architectural Association, where it quickly became clear that he had taken the wrong subjects at A-level and could not be offered a place. The information came as a complete shock to the adolescent, who had just sat his exams, and he returned home despondent and without any idea of what to do next. His father offered to help him get a job in one of the professions – banking or accountancy. Panicked by these possibilities, Slee surprised himself by saying that he would like to go to art school, a suggestion of his sister's rather than an idea of his own. He had one friend at Carlisle College of Art, but otherwise knew nothing about it, having dropped art from his studies at the age of 14. His friend advised him on building a portfolio for his interview (Slee recalls some 'dreadful landscape drawings') and he was enrolled for the Pre-Diploma Course in 1964.

His reports from Carlisle College of Art show Slee to have been a highly regarded student and he admits that 'a world opened up for me'. The students tasted a bit of everything; they were taught basic design exercises (heavily influenced by Bauhaus principles), they experimented with life drawing and life modelling, sculpture and painting, and were able to set their activities in the context of the art history lectures they heard. That a member of staff could speak at length on the subject of drawing was a revelation, but as important as any tutors was the exceptionally good library, where Slee found two books that remain key works for him – Albers' *Interaction of Colour* and Klee's *Thinking Eye*.[2] Under the supervision of David Green in the ceramics department, he discovered a talent for making hand-built pieces, heavily influenced by Scandinavian ceramics that he had seen in magazines and design yearbooks. Through publications such as *Art International*, Slee became aware of the work of the sculptors Eduardo Paolozzi (b.1924) and Phillip King (b.1934). The latter's sharp blue *Genghis Khan* especially caught his attention and he was frustrated that it was impossible to achieve a similar colour in ceramics among the muted 'craft' choices on offer. Even this early on he remembers being mystified by Green's excitement at making quantities of small bowls (which all looked the same to Slee) and his tutor's delight in discovering a slight variation in a green or brown. Already he craved bright, primary colours and rebelled

8  Central School of Art and
   Design Diploma Show
   1970
   Photograph: Unknown

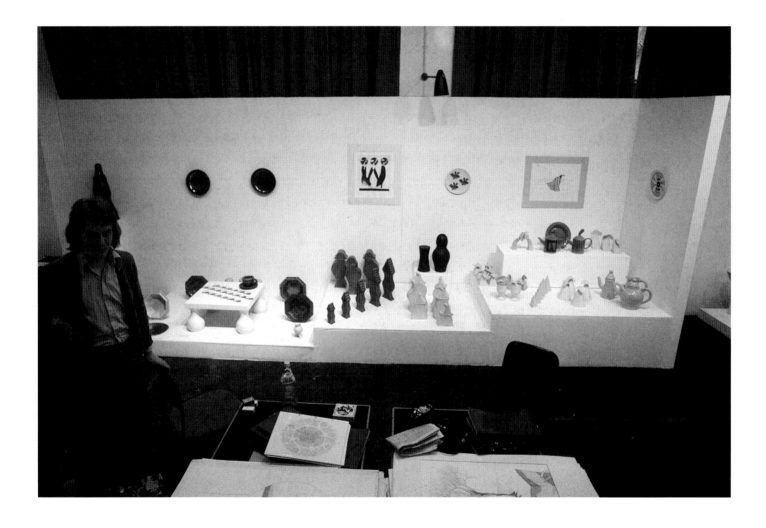

9 **King** 1965
Student work from Carlisle College
of Art
H. 20 cm; 8 in
Photograph: Geoffrey Sheard

against being caught in any particular style of making. Although Slee would not have known it at the time because no ceramic history was taught, Green's roots were in the Modernist school, a world that held no appeal for his student either in terms of form or philosophy. The differences between them, however, did not prevent Green including an illustration of one of his pupil's pieces, *King*, in a book he published on glaze chemistry.

There seems to have been no 'eureka' moment, and when the course ended Slee knew only that he did not want to be a painter. Perhaps because of his Engineering Drawing A-level and a recently expressed interest in ergonomics, his tutor recommended the Industrial Design course at Central School of Art and Design in London, which Slee signed up for in 1965. Hating the course, he soon ceased to go to classes and, miserably, assumed he would have to leave, and it was almost by chance that he found himself switched to Central's ceramics course run by the progressive educationalist Gilbert Harding Green (1906–83) and based at Red Lion Square. Describing himself as 'a child of my environment', the misjudged advice from Carlisle had led Slee to exactly the vein of knowledge that inspired him. At Central, studio practice was balanced with lectures on ceramic history evincing particular enthusiasm for the work of European factories, and he discovered a love of the eighteenth century and the inventiveness of British manufacturers such as Whieldon and Wedgwood. The students were taken to Stoke-on-Trent where their eyes were opened to the breadth of possibilities, visiting not just the Minton factory and Wheatley's, a floor-tile manufacturer whose products and procedures seemed little changed from its Victorian beginnings, but also Buller's, whose output ranged from minute ceramic parts used in electrical components to vast insulators for power stations.

The period techniques described in lectures were not only visible in the exhibits at the Victoria and Albert Museum – where, among other discoveries, Slee thrilled to the sharp colour combinations of Sèvres porcelain – but were also revived in the studios at Central, lending new life to the theory and laying the foundation for an absorption with problems of construction that is at the heart of Slee's creativity. A collagist in his intellect and

imagination, he incorporated aspects of ceramic history into his own practice without seeing any need to siphon them off from the contemporary ideas all around him at the college, in London's Cork Street (where, at the Kasmin Gallery in 1968 and 1970, he saw shows of Ken Price, an American ceramicist born in 1935, whom he much admires) and in the wider world. A typical Slee work may contain references to furniture, politics, sociology, a novel he has enjoyed or a scene from a film, alongside an echo of a Surrealist object, a taste of Sèvres or Victoriana and, possibly, a joke. Armed with a degree of detachment, his student pieces began to reflect a wry commentary on accepted ideas about ceramics and their traditional forms. He had no difficulty in fulfilling the stipulation that the degree show reflect skills from a wide range of practices – throwing, hand-building, mould-making, firing at different temperatures, an understanding of the chemistry of glazes, of different clay bodies and of printing techniques – and graduated with First Class Honours in 1970. Included in the show was a pot with abbreviated jeans and a pair of 'bovver boy' boots. As its makers acknowledge, the *Walking Tea Set* which, clad in bright stripey socks, tripped sweetly over so many British tables in the 1970s, owes its genesis to this less sugary piece.

Despite his success at Central, Slee left without any firm belief that his future lay in ceramics. With no access to a kiln or other equipment, his creative energies took the form of drawing and collage while he meandered through a series of jobs. A return visit to Central's 1971 degree show brought him back into contact with his former tutor, Dan Arbeid (b.1928), who invited him to use his own studio near Saffron Waldon over the summer. This arrangement not only provided Slee with a series of 'givens' in terms of the clay body (stoneware) and kiln size (large), but also, through Arbeid's friend, Jerome Abbo, a technician in the ceramics department at Central, led to his being taken on as the junior technician at the college in the autumn of 1971. The return to Central was important for teaching Slee how to run an efficient studio (he eventually took over Abbo's job when the latter moved to Harrow School of Art), for returning him to an environment where he continued to learn through solving students' technical problems, and also for giving him steady access to materials and equipment again. *Dogs and Grass* (1972), made for an urban

10  **Dogs and Grass**  1972
H. 30 cm x 4 m³, 11.75 in x 13 ft²
Private collection
Photograph: Richard Slee

22 11 Work produced at Dan
Arbeid's studio  1971
H. 22 cm; 8.75 in average
Collection: Jeffery Pine
Photograph: Tim Street Porter

garden, dates from this period. It is based on a Scottie dog jigsaw puzzle piece scaled up with a drawing and then a cardboard template to produce a clay version just smaller than life-size. A scale 'slightly larger than you would expect' has become a characteristic of much of Slee's output. He is not, however, interested in working beyond the natural limits of the material – the challenge of producing a life-size ceramic human figure, for example, is one he can easily dismiss – but the composite (and rearrangeable) nature of *Dogs and Grass* was another strategy for making a larger work, and one that he is currently exploring in preparation for his 2003 Tate St Ives exhibition. The pun and the stylisation of the blue grass in which the dogs frolic were also signs of what was to come from the studio in the future.

An invitation to go to Macedonia to translate a vast abstract painting by Petar Mazev (b.1927) into a ceramic mural not only brought Slee's contract with Central to a close in 1973 but also ended his dreams that socialism could provide a practical alternative political system. After a gruelling six months he returned to Britain and took up a full-time teaching post at Hastings College of Art, hired a studio nearby and used the college's kiln. The studio rent covered the cost of clay, so he began using what was provided – earthenware – and concentrated on simple, one-colour glazes. His output of this period was inspired by the 1930s, fed partly by objects bought from local jumble sales that he would visit at weekends in the company of Diana Gill, a student of ceramics he had met while working as a technician at Central and whom he was to marry in 1977. Never a serious collector before, Slee began to accumulate a hoard that he still keeps in his attic for reference. *Appropriated Rabbit* (2002) is a scaled up version of a Hastings jumble sale find, and among the few objects on display on the high shelves in his home are a pair of pink vases from the same source.

If Slee enjoyed his immersion in the 'ocean liner' architecture of Hastings, it had nothing like the impact of his five-day stay in Las Vegas during his first visit to America in 1974. He loved its brashness: 'It was like landing on the moon. So courageous. Every corner would make me gasp. I walked up the Strip in 120 degrees with my Pentax glued to my eyeballs. Everyone

12  Las Vegas Strip, USA  1974
Photograph: Richard Slee

13  **Cow Girl, USA**  1974
Earthenware
H. 21 cm; 8.25 in
Collection: the Artist
Photograph: Richard Slee

24

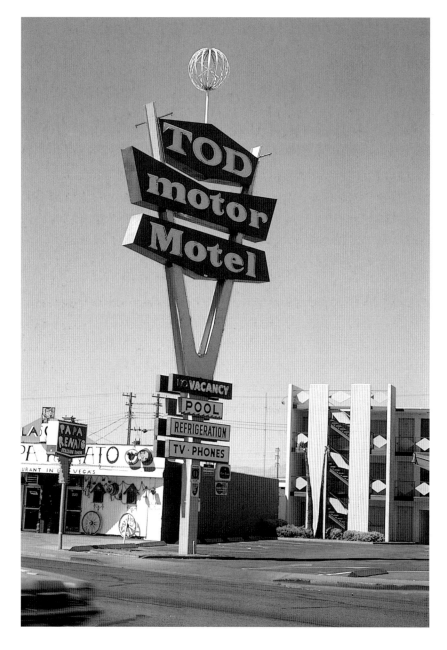

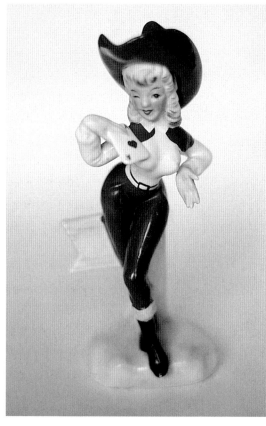

else was in their air-conditioned cars and thought I was mad.' He came back with seven rolls of film, not only photographs of the casino architecture but also of the signage, fascinated by its use of geometric abstractions, 'elements of Modernism used commercially'. *Vase* (1977) is an example of how these sights seeped into his work on his return. Most of his six weeks in America were based in Los Angeles, where a friend's collection of American ceramic refrigerator jugs fired Slee's imagination almost as much as Las Vegas. The jugs, mainly made by Hall and Company, were mass produced and given away with the fridges: 'I found these incredibly exciting because they had no ceramic history. I loved their colours – powder blues and pinks – and the fact that they were streamlined. They were so inventive.' Among the souvenirs he brought home was an ornamental cowgirl holding an ace of spades, who was to live on his mantelpiece for years and remains in his possession.

The American influences are visible in several jugs made in the 1970s, with their sloping sides and sense of movement. Slee acknowledges Disney's animation as another ingredient, particularly the dancing brooms from *Fantasia*, although this stemmed not from seeing the film sequence but from a book of stills purchased just after leaving Central: 'It's the drawing that's the important thing, not the movement.' The Disney flavour of the jugs and *Crutch Vase* (1977) mixed, characteristically, with a broad range of other influences – from Pre-Columbian to Pop Art – in Slee's first one-man show, held at Smith + Others Gallery in Kensington in 1977. He was attracted to the gallery space because it looked more like a shop than a gallery and, determined to avoid the atmosphere of piety he so disliked in craft exhibitions, filled it with about 60 pieces to turn it into 'a boutique from another land'. Throughout his career Slee has preferred his pieces to be seen in the context of one another rather than in isolation, and they now take their place in the ceramic vocabulary that he has built during a span of over 30 years. He has kept faith with his wish to evolve a recognisable language while evading the trap of a self-generating style.

The intense activity leading up to the 1977 exhibition was followed by a hiatus during which Slee made nothing in the studio. He and Diana moved to Brighton (where their

14 **Vase** 1977
H. 30 cm; 11.75 in
Private collection
Photograph: Philip Sayer

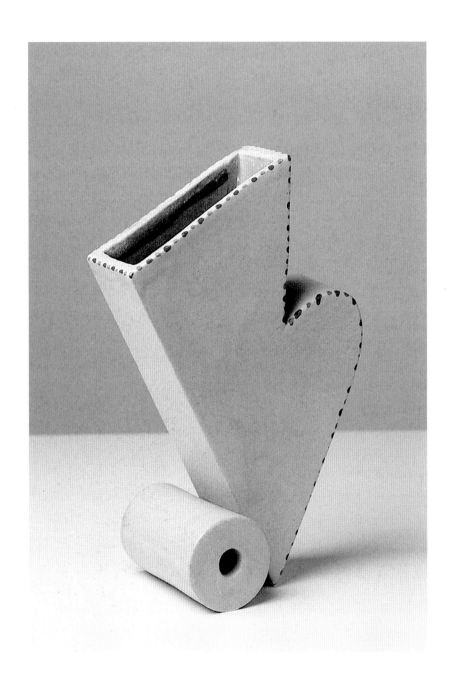

15 **Crutch Vase** 1977
   ll. 25.5 cm; 10 in
   Collection: Jeffery Pine
   Photograph: Zul

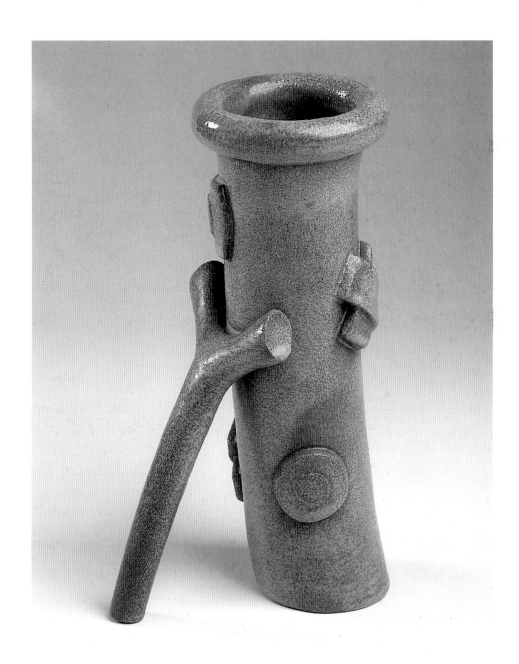

daughter, Pearl, was born in 1978) and purchased a Victorian house so run down that the terms of the mortgage insisted on drastic reconstruction; having limited funds, they set about restoring it themselves. Slee was by now lecturing part-time at both Harrow School of Art and at Central, and although the house and childcare took up all non-teaching time for nearly two years, both activities were to feed into his work on many levels. The house itself was intriguing and possibly first owned by a carpenter (there was a banister that began traditionally but ended in a snake's head with a gas pipe in its mouth) and, in researching its restoration, Slee began to consider contemporary potters such as the idiosyncratic Martin Brothers and Sir Christopher Dresser (1834–1904), whose inventiveness he had always admired. Brighton Museum yielded a jug (circa 1910) by Sir Edmund Elton (1846–1920) sporting a fish as both handle and spout as if it had passed through the vessel; Slee remembers feeling jealous that he had not made it himself. His pleasure in the period was all the greater for remembering Pevsner's dismissive comments of the Great Exhibition and his own awareness of the disregard in which the era was held by many of his former tutors and most of their students.

Eventually the studio in the basement of the house was fit for use, equipped simply with a small kiln, a spray-gun, compressor and a table (apart from some early use of press-moulds, virtually all Slee's pieces have been hand-built; it was only in 2002 that he first bought a wheel) and he embarked on a period of experimentation. He began using a mix of two commercial clays to achieve a higher degree of plasticity so he could model the details for pieces such as *Jar* (1982), whose rounded body stands on three tapering legs and rises to a whiff of smoke, playing on the notion of 'zoning' (where a definite foot, body and neck can be discerned) as an antidote to the flowing Modernist shapes so beloved by Bernard Leach (1897–1979) and his followers. The nearest he got to a flowing rhythm himself was with a series of cornucopias, a form neglected by fellow practitioners and one symbolic of opulence and decadence, qualities alien to Slee's self-disciplined character but which he finds alluring. He began to introduce textures, building a library of reusable samples cast in plaster from everyday surfaces; cork, crumpled Bacofoil, a piece of rope. (A bizarre 2002 addition was

16  First Solo Show Poster  1977
Collection: the Artist

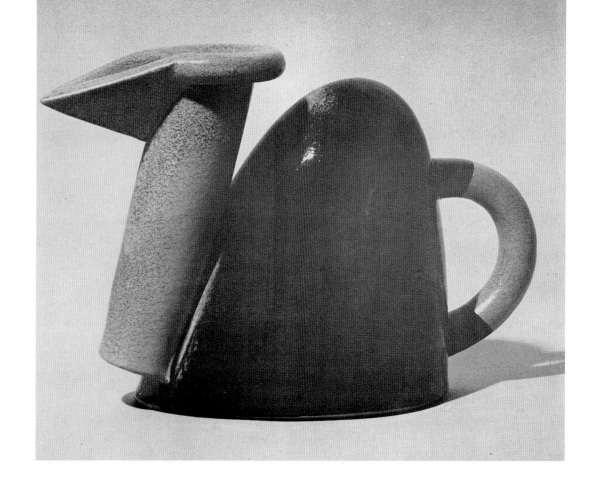

Timo Sarpaneva for Iittala

17 **Birdbottle** 1957

(Centre) Blue glass

H. 17 cm; 6.75 in

Collection: Mr and Mrs Slee

Photograph: Richard Slee

Sir Edmund Elton

18 **Jug** *c.*1910

Earthenware, crackled glaze of

liquid platinum over gold

H. 24.5 cm; 9.65 in

Collection: Brighton Museum

and Art Gallery

Photograph: The Royal Pavilion,

Libraries & Museums, Brighton

30

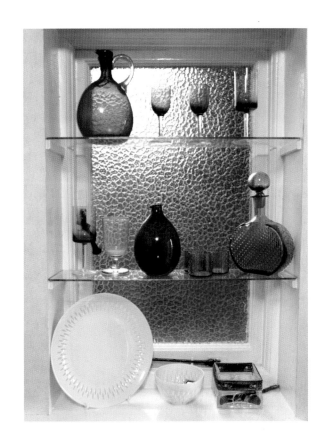

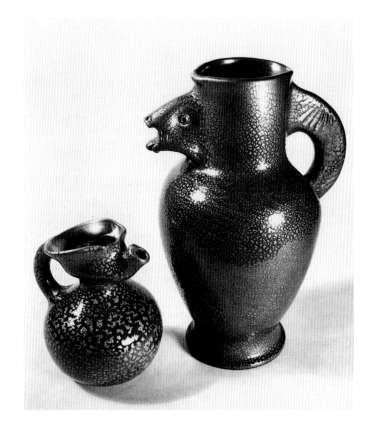

19 **Jar** 1982
H. 30 cm; 11.75 in
Private collection
Photograph: Philip Sayer

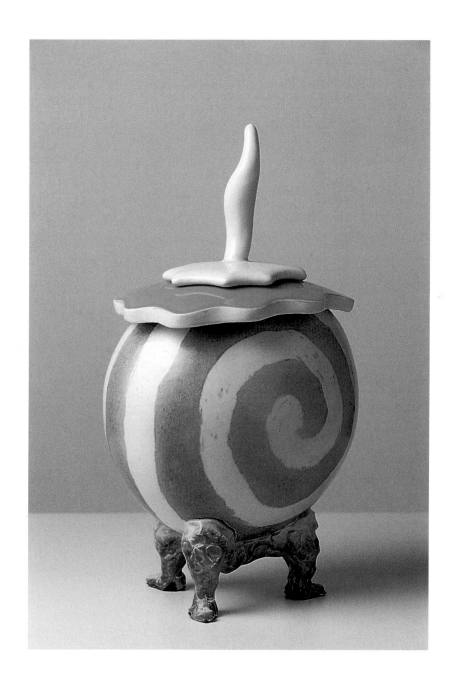

cast from frozen chickens' feet bought for 99 pence from Peckham Rye Market.) Despite his focus on Victoriana, Slee did not allow himself to be pigeon-holed; contemporaneous pieces include *South Sea Island Dish* (1980), made after being seduced by the form of a South Sea wooden platter, and *K Teapot* (1980), an exuberant homage to George Herriman's (1880–1944) Krazy Kat cartoons. Sharper colours edged out the more muted tones of the 1977 show. Although he has consciously limited its influence, the presence of the Brighton Pavilion began to season his thinking.

This fertile phase came to an end when Slee's mood darkened. He and Diana separated in 1984 and were to divorce three years later. He moved to his present Brighton home (a former shop and premises above), converting his studio before the living accommodation and acquiring a larger, electrical kiln with computerised controls. His output took on an overtly autobiographical slant, most poignantly in *Disappearing Heart* (1988), whilst *Barrel and Glass* (1988) reflects the partial solace he found in alcohol as well as his loathing of anachronistic ceramic goblets. The mood of self-analysis spread to a wider canvas in the irksome Thatcher years, triggering *Anvil* (1986), a summation of frustration and irony (a beating block that will shatter if hammered; a symbol of socialism as the Iron Curtain fell) and *Sheath* (1988), partially a response to the growing Aids crisis. Royal weddings provoked the pottery crowns which he, a natural republican, made with the phrase 'a wooden nickel' in mind, mulling on the fluid notion of value; in ceramic terms he has always kicked against the acceptance of porcelain's superiority. Not everything of this period was born of distemper, however, and Slee's concentration on the problems of construction was as alive as ever – *Pod* (1987, Crafts Council collection) was an exuberant exploration of volume, and *Reclining Heart* (1987) was perhaps an indication that the worst of the heartache was over.

20  **South Sea Island Dish**  1980
W. 34 cm; 13.5 in
Collection: the Artist
Photograph: Zul

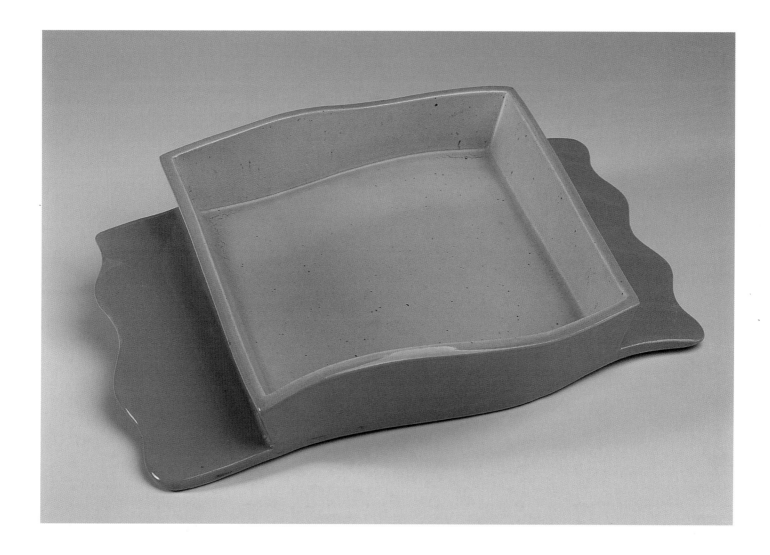

21 **K Teapot** 1980
H. 23.5 cm; 9.25 in
Collection: the Artist
Photograph: Zul

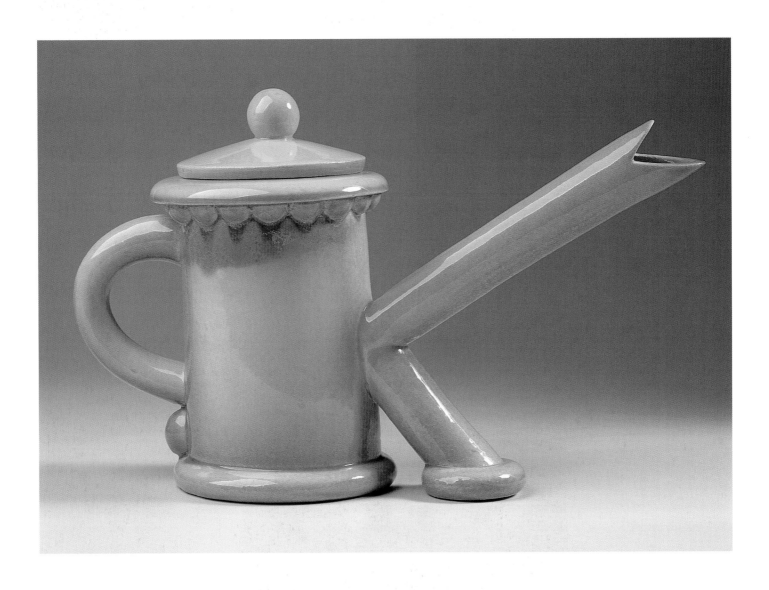

22  Richard Slee at
    his Brighton Studio  1984
    Photograph: Andrew Greaves

23  **Anvil**  1986
    H. 46 cm; 18 in
    Collection: Destroyed
    Photograph: Richard Slee

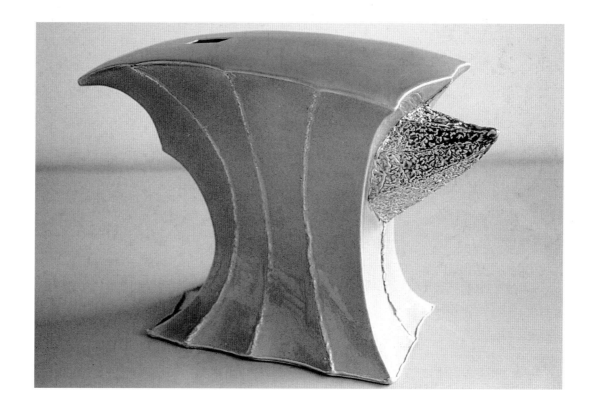

24 **Pod** 1987
W. 56 cm; 22 in
Collection: Crafts Council, London
Photograph: Tim Hill

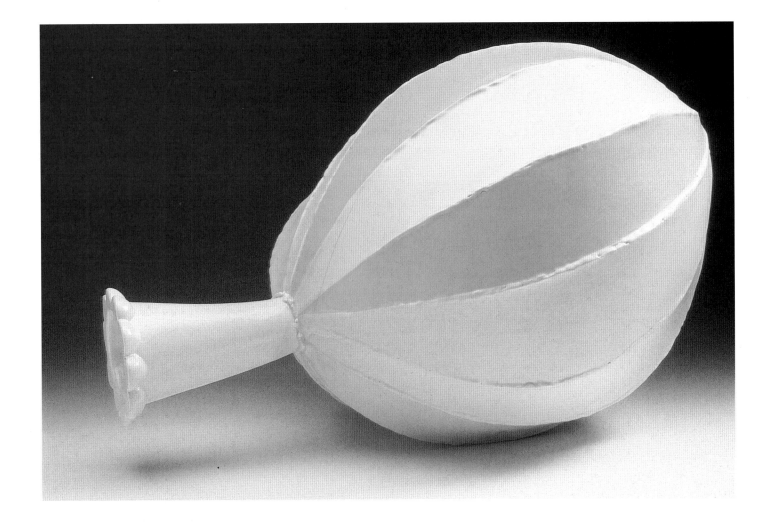

25 **Reclining Heart** 1987
l 51 cm; 20 in
Collection: the Artist
Photograph: Zul

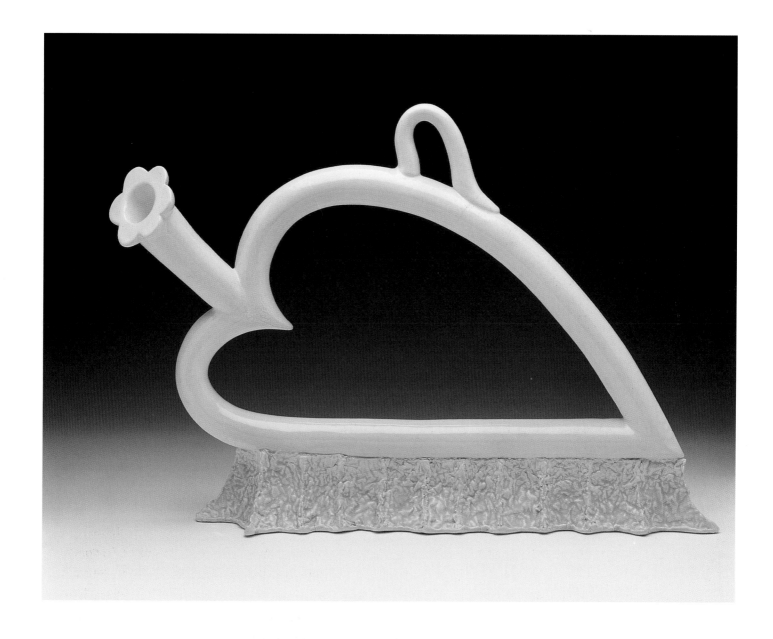

A Degree by Project undertaken at the Royal College of Art (1986–8) enabled Slee to invent a clay body to achieve the freedom he wanted for future work. He required something lighter, smoother and even more plastic and, after painstaking research to discover the ingredients, used it first at the RCA to make a series of printed plates and then in the studio to fully explore the possibilities his recipe had opened up. In a conscious effort to raise his spirits, he began the 'spring' pieces, such as *Flower* (1989, based on a delftware tile, with a little shot of the 'Woolmark' logo added) and *Bud* (1990, Crafts Council collection), which would have been impossible to construct without the new clay body, the tougher surface of which also took on a shinier glaze, bringing purer colour and a more reflective surface. Sales of this work were satisfying – Slee was by now selling to public and private collections and exhibiting in Europe and America (in the 1990s invitations to Korea added another ingredient to his work). An important outlet was the Crafts Council shop in the Victoria and Albert Museum, run by Tatiana Marsden, who had seen his work at the Gallerie Het, Kapelhuis in Holland in 1982 and gave him a solo show at the V&A shop the following year. She was later to champion his work at the British Crafts Centre and, along with Juliana Barrett, at the Barrett Marsden Gallery, where Slee has had one-man shows since 1998.

Although teaching has meant Slee is not dependent on selling (he was made Professor of the London Institute in 1992), his practice has been affected by the ups and downs of the market, usually a reflection of the wider economy. A dip in fortunes meaning that he had no show to work towards was responsible for his first figurative piece since leaving Central, *Drunk Punch* (1991), now in the V&A. It was an alarming step because Slee lacked confidence that he would succeed, but it led to an exuberant flow of Punches, toby jugs and idyllic scenic pieces that take a satirical look at the traditional notion of 'Englishness', such as *Stile* (1996) with its hangman's noose (triggered by reading *A Handbook on Hanging*, published in 1929). *Jar* (1996, owned by fellow-ceramicist Alison Britton) has its source in mock coaching lanterns noticed on Brighton houses (he likes to walk for a couple of hours each day) and this, along with *Anvil*, is a rare example of what Slee calls 'full stop pieces', which he feels could not be bettered by changing in any way. Asked if he is aiming at beauty, he answers, 'No: completeness'.

26 **Tiara** 1988
Diam. 29 cm; 11.5 in
Collection: the Artist
Photograph: Zul

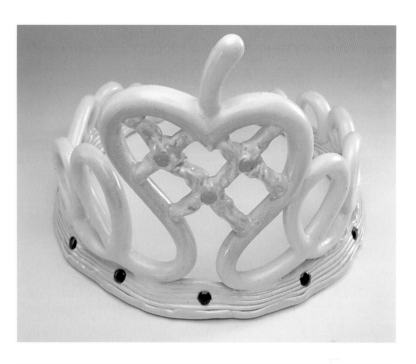

27 **Barrel and Glass** 1988
H. 45 cm; 17.75 in
Private collection
Photograph: Zul

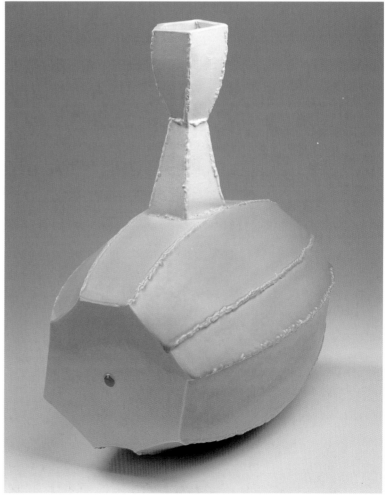

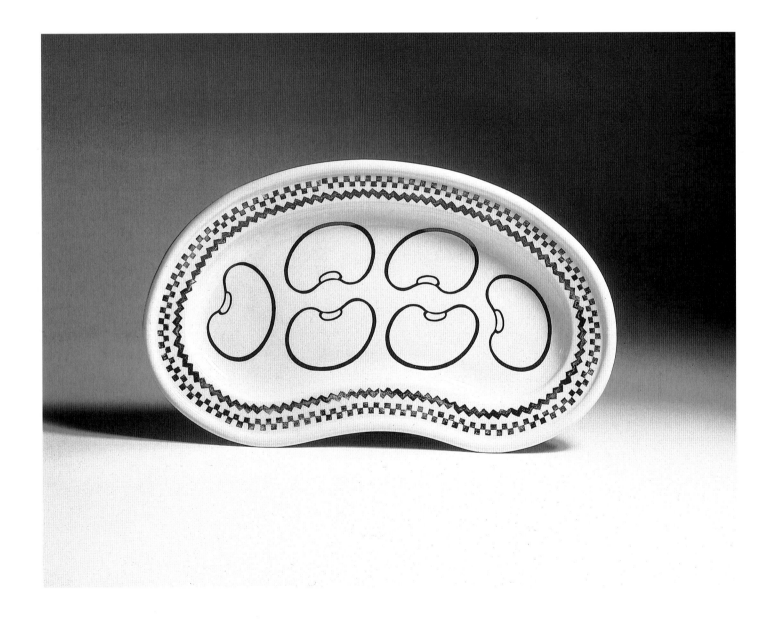

**29 Disappearing Heart** 1988
l. 48 cm; 19 in
Private collection
Photograph: David Cripps

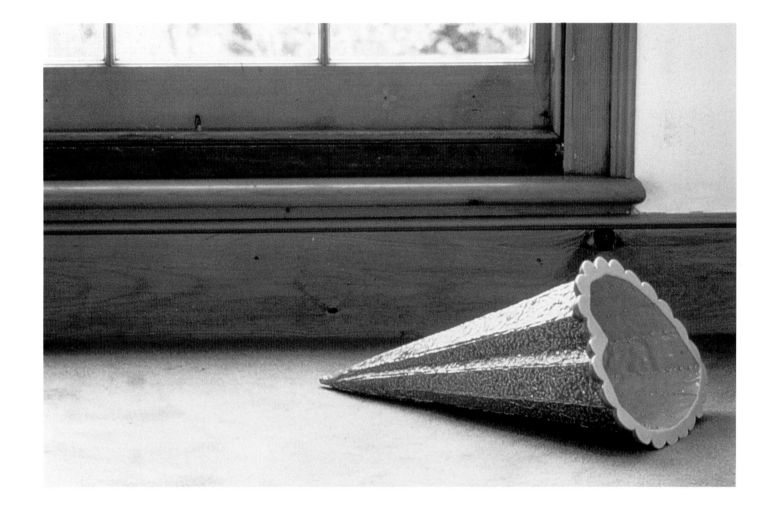

30 **Bud** 1990

H. 45 cm; 17.75 in

Collection: Crafts Council, London

Photograph: Ian Dobbie

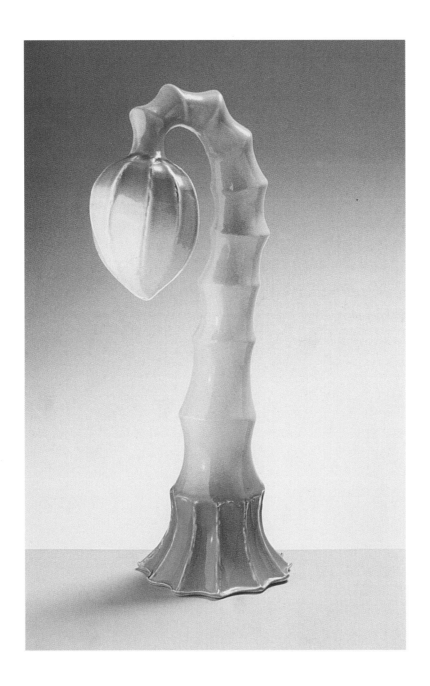

**31 Flower** 1989
H. 42 cm; 16 in
Private collection
Photograph: Zul

**32 Stile** 1996
H. 44 cm; 17.5 in
Private collection
Photograph: Zul

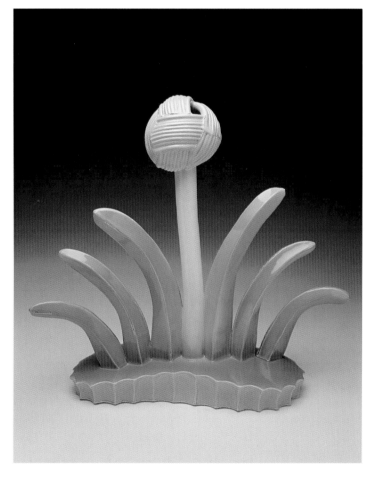

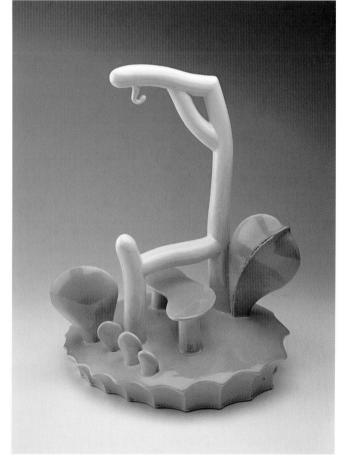

33 **Wastebasket** 1999
Diam. 40 cm; 15.75 in
Private collection
Photograph: Richard Slee

By the late 1990s found objects began to appear in the work. Many were collected by his young daughter when she accompanied him to car boot sales searching for treasures. (Fatherhood has been and is important to Slee, who also believes time playing with Pearl and her toys has fed into his work; *Tiara* (1988) was made for her.) When his daughter reached adolescence and presented him with a bin-bag full of the china ornaments she no longer wanted, Slee found himself unable to throw them away and gradually began to subvert them by creating new contexts for them, lending a hint of eroticism to a pair of china angels (*Angel*, 1998) and converting a plate into a miniature Hollywood Bowl for the Cinderella figure in *Blue* (2000). In a typical Slee amalgam of practicality and commentary, *Wheelbarrow of the Medusa* (2001) is not only a gesture towards Théodore Géricault's (1791–1824) *The Raft of the Medusa* but brings this sequence to a close by loading the remaining figures from Pearl's bin-bag into a modelled wheelbarrow.

Recent invitations and commissions have broadened the stage for Slee's output and his show at Tate St Ives is indicative of a wider awareness of his achievement. Lingering architectural ambitions may have been assuaged by *Coldframes* (2000), made for the Goodwood Sculpture Park, an outdoor construction using the mini-bricks found in McDonald's fast-food restaurants' interiors. The piece encapsulates themes constant throughout his career, the printed ceramic windows 'growing' a mini history of the decorative arts in the form of stylised flowers from differing periods and sources. An as yet unrealised proposal for Grizedale Sculpture Park parallels the verdant grasslands of Cumbria with the green of the Macintosh computer screen, and, if it comes to fruition, would be his first major non-ceramic piece, dotting vertical 'files' of Lakeland slate across a valley like computer icons. Slee's own armoury of computer technology has been updated thanks to the award of the 2001 Jerwood Prize for Applied Art, a development not only good for his reputation and confidence but also his bank balance. He uses the computer mainly as a drawing and scanning tool – *Morris Men* (2000) uses a modified image purloined from a sweet wrapper, while *Wastebasket* (1999) steals the Mac's own trash can symbol.

34 **Jar** 1996
H. 48 cm; 19 in
Private collection
Photograph: Philip Sayer

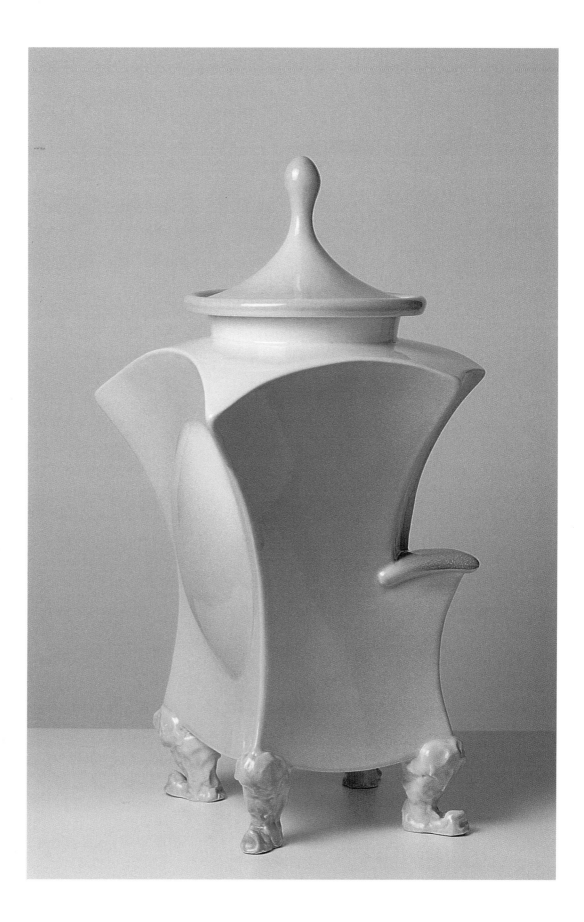

35 **Angel** 1998
With additions
H. 42 cm; 16.5 in
Private collection
Photograph: Zul

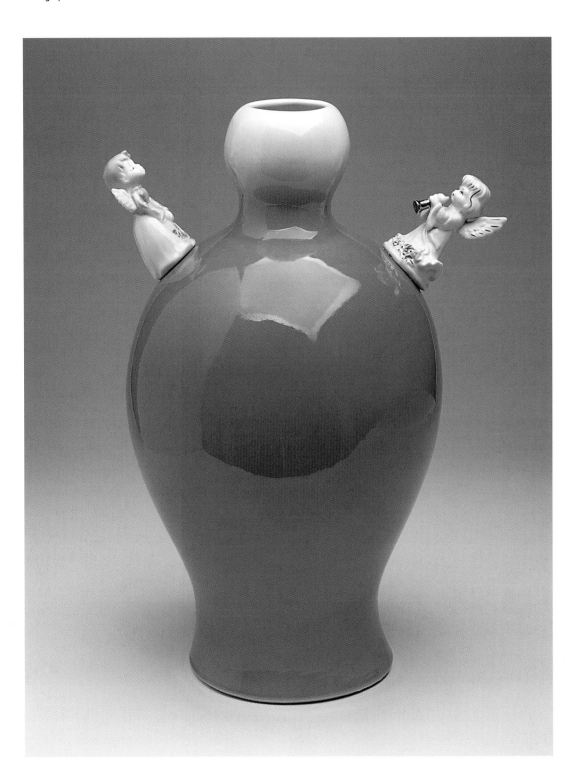

## 36 **Coldframes** 2000

Ceramic, ceramic brick veneer, steel
W. 280 cm; 110 in
Collection: Goodwood Sculpture Park
Photograph: Sculpture at Goodwood

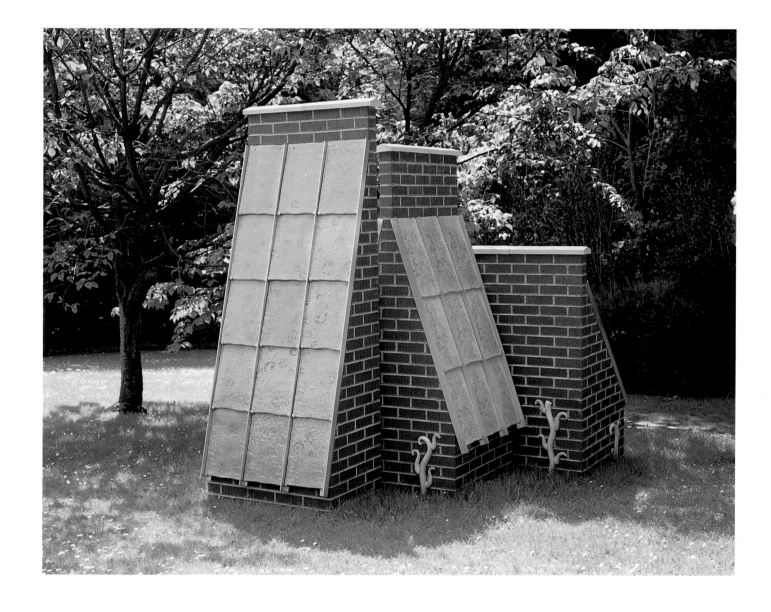

37 **Blue** 2000
With addition
H. 37 cm; 14.5 in
Collection: The Potteries Museum
& Art Gallery, Stoke-on-Trent
Purchased by the Contemporary
Art Society Special Collection
Scheme with funds from the
Arts Council Lottery, 2001
Photograph: Philip Sayer

38 **Morris Men** 2000
Diam. 42 cm; 16.5 in
Private collection
Photograph: Philip Sayer

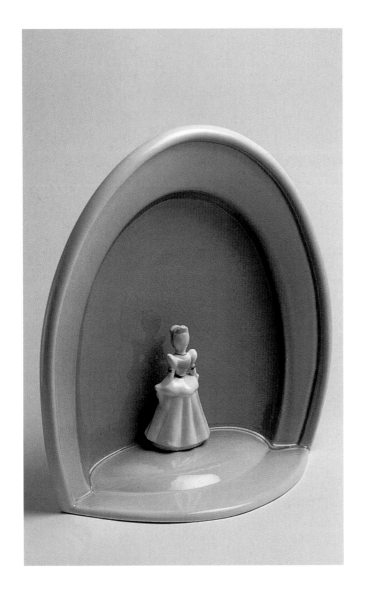

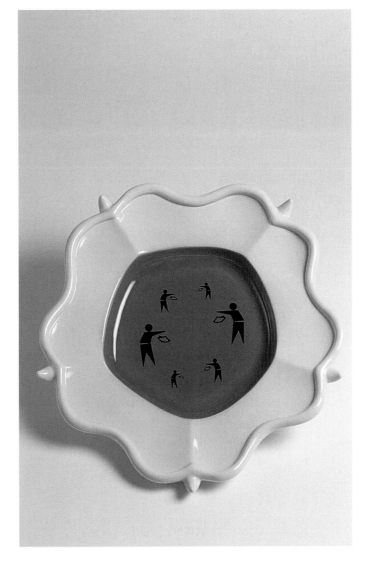

Back in a happy relationship (with the design historian Linda Sandino), Slee has begun the twenty-first century as fluently and as full of contradiction as ever. If his references are eclectic, they are never vague and rarely simple. The smiling *Speech Bubbles* (2001), handmade to look so smoothly manufactured that they might have rolled out of a giant sweet packet, have their source in Thomas Rowlandson's (1756–1827) prints. The huge candlestick just out of the kiln owes its existence to a detail from Hogarth's (1697–1764) *Analysis of Beauty*, and is part of Slee's current investigation into the nature of domestic elegance. Experiments so far suggest that symmetry is a necessary component of elegance, hence the new wheel which has joined the studio equipment. No one need fear that Slee is about to become conventional, though. A charity shop mug tree (bought to research its structure – upright, upended, lying down) and a Yule log mould (a tool for the St Ives commission) lie alongside.

**Notes**

1  Direct quotations from Richard Slee are taken from his National Life Story Collection recording at the British Library Sound Archive. The recording was made in 2002 and was supported by the Jerwood Foundation.

2  Josef Albers, *Interaction of Color*, Yale University Press, 1975; *The Thinking Eye: The Notebooks of Paul Klee*, edited by Jürg Spiller (translated by Ralph Manheim), Lund Humphries, London, 1961.

39 **Wheelbarrow of the Medusa**
2001
With additions
H. 29 cm; 11.5 in
Private collection
Photograph: Philip Sayer

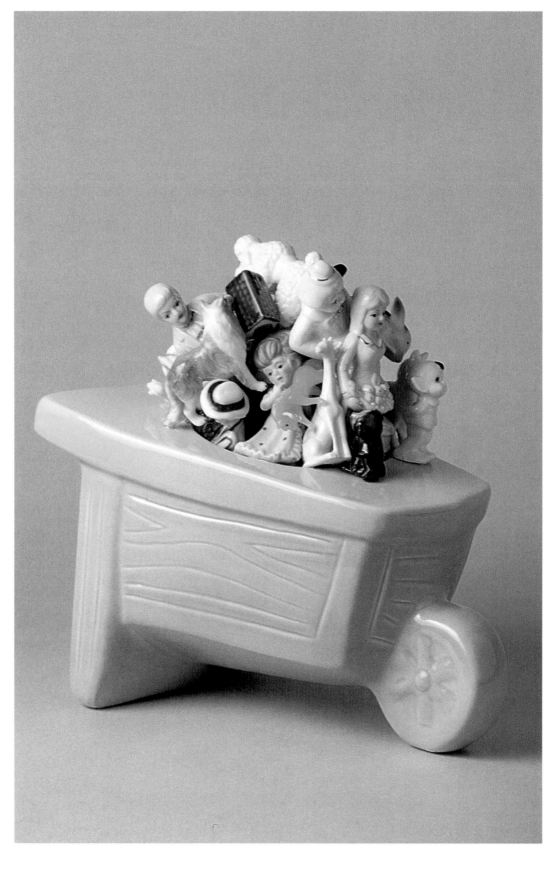

40  **Speech Bubbles**  2001
With underglaze print
H. 34 cm; 13.5 in tallest
Private collection
Photograph: Philip Sayer

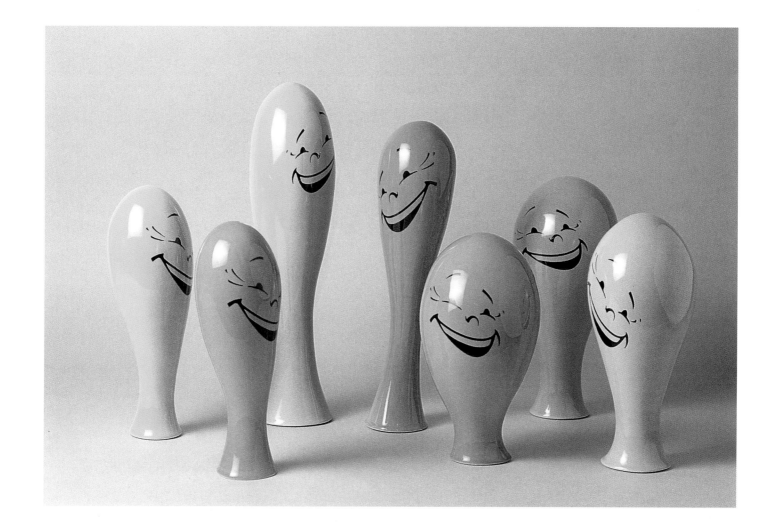

52    41 **Chicken Feet** 2002
       L. 50 cm; 19.75 in
       Collection: the Artist
       Photograph: Philip Sayer

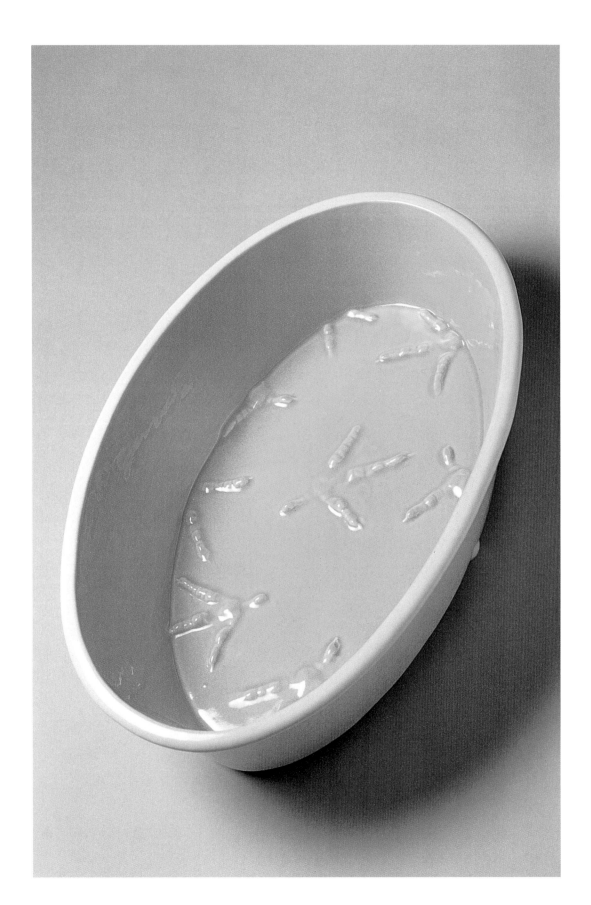

42 **Hogarth's Candlestick** 2002
H. 50 cm; 19.75 in
Private collection
Photograph: Philip Sayer

43 **Tree** 2002
With additions
H. 46 cm; 18 in
Collection: the Artist
Photograph: Philip Sayer

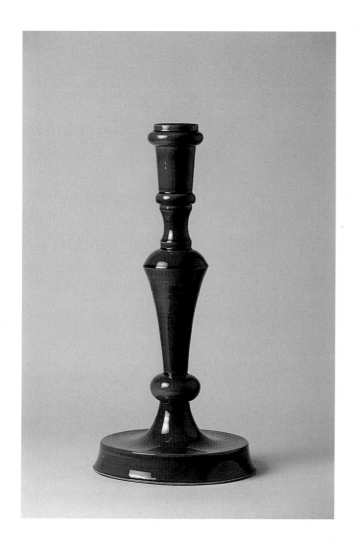

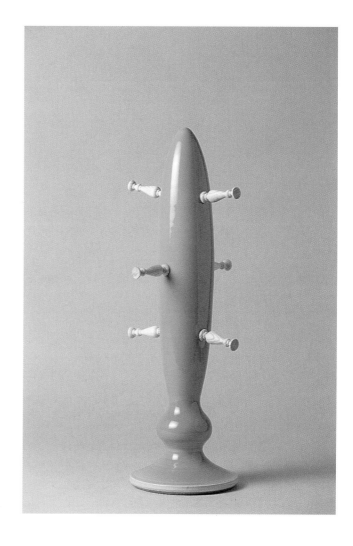

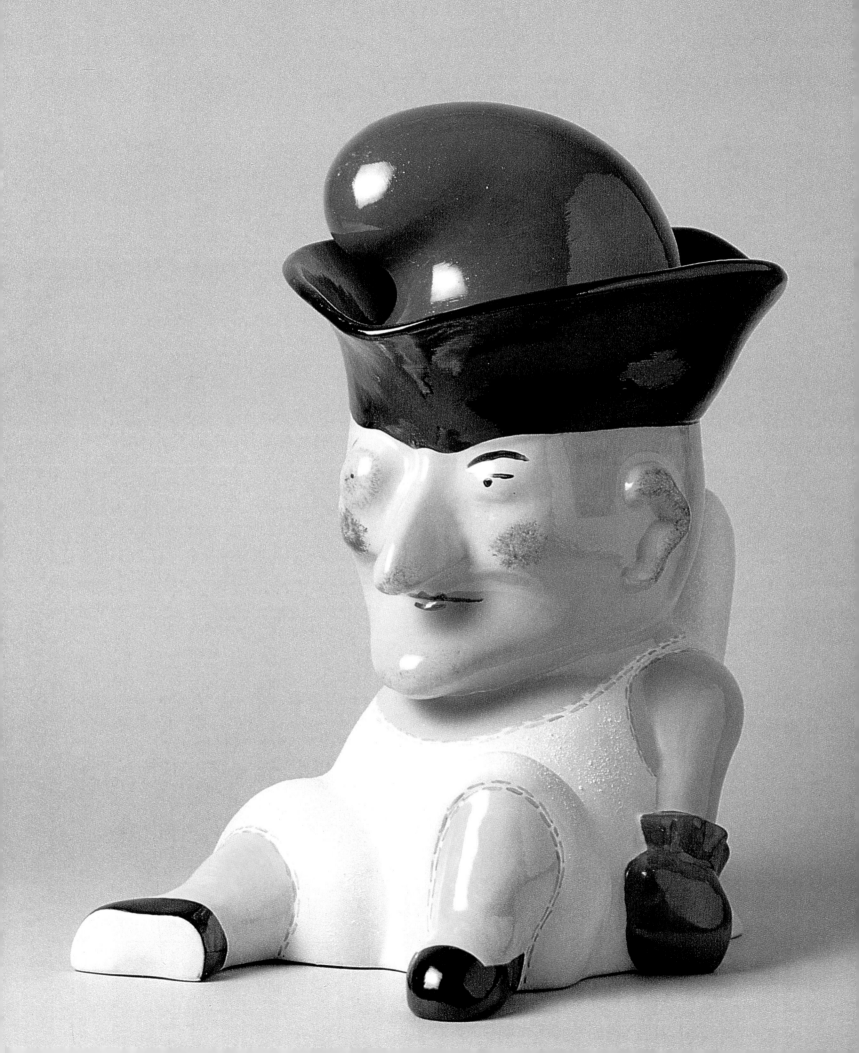

# 'Resident alien': Richard Slee in context
## Garth Clark

One of the most fascinating aspects of Richard Slee's three-decade-long career is the parallel struggle by writers and critics to wrestle his sly and slippery output of ceramics into a craft context. A few have taken another tack and argued early on that he is a Punk artist or, as Christopher Reid, writer on the arts, contends, an 'anti-ceramist'. But for the most part the persistent goal of critics and essayists has been to find a way to convincingly place Slee at the centre of the British crafts movement. When the thesis becomes too thin and unconvincing they play the trump card, saying that he belongs, 'because the artist himself says so'.

The critic Herbert Read always warned young critics to be suspicious of what artists say about their work. Marc Chagall (1887–1985) agreed, adding that 'first I paint the painting then I imagine things to say about it'. Writers should have been less ready to accept Slee's self-designation as a potter at face value. At one point, writer on the crafts John Houston even declared him to be 'a craft potter and proud of it'.[1] The sculptor Richard Deacon (b.1949) posited him as a functionalist even though his work was barely utilitarian.[2] More recently Oliver Watson, Keeper of Ceramics at the Victoria and Albert Museum, argued that he was a craftsman although, to his credit, he sounded more than a little sceptical as he proposed the concept.[3]

There is a comic edge in reading these attempts to take this unruly jack-in-the-box of studio pottery and compress his spring-loaded art into a craft box he clearly does not fit. He contradicts almost everything the crafts stand for and yet the commentators have persisted in claiming him for this movement. Arguably, the only writing on Slee that truly pinpoints what he is about is the artist Grayson Perry's informal but revealing essay that blithely dismisses Slee's protestations of craft membership and then proceeds to reveal a much more personal and engaging view of his art and its curiously gentle acts of sedition.[4]

To be fair, there was a time when Slee genuinely saw himself as part of the crafts world. Maybe he still does, but it seems doubtful. At other times the absurdity of his polychromatic ceramics being lumped in with tenmoku glazed mugs and jugs appealed to his finely tuned

sense of the ridiculous. Moreover, while Slee is sociable he is also very much a loner. Club membership is not his inclination so what is better than to claim membership of a body you *know* you do not belong to. Then again, maybe he was just waiting to see how long it would take for someone to call his bluff.

Many from the crafts world do not see him as a member of the clan. Watson points out that some dismiss him as, 'a maker of trivial, kitsch baubles – futile, irrelevant and adolescent gestures against establishment mainstream'.[5] In turn his work has that bothersome slightly facetious edge that leads us to wonder if we are *all* implicated in his parodies: 'I felt his work was telling somebody off,' writes Perry, 'but who? Potters for bouncing around self-indulgent micro ideas in their own cosy world? Sleek minimal modernists for taking themselves too seriously? Were those smiley faced toby jugs laughing at New Britain taking Ecstasy or at the heritage industry clinging on to Olde England?'[6]

The more progressive craft artists have embraced Slee's presence and admired his vision, energy and wit. Collectors on the other hand are only now beginning to come around to appreciating his work. Slee has grown accustomed to the crafts being his home and, one suspects, enjoys the freedom (aka benign neglect) of being part of a marginalised group. In turn he has been a good neighbour, a respected teacher and a voice of reason and light at conferences and other gatherings. This does not mean that his work is about the crafts. Ideologically, apart from the slender thread of making his objects himself, his work has little to do with the craft movement's values and certainly not enough for this to be the primary way of defining or contextualising his art.

If he is not a craftsman then what is he and why is he in this world? His relationship is best described as that of being the craft world's 'resident alien'. This strangely sci-fi sounding term is what the US Immigration Department calls 'green card' holders – those who are permanent residents in the United States but not citizens. This makes perfect sense as a metaphor as it explains Slee's duality, both an insider and an outsider at the same time;

part of the reason why placing him in the crafts context has proved to be both so tempting and yet so elusive.

His creative passport was issued elsewhere and is not signed by William Morris, Bernard Leach or any of the gurus of craft. Slee is something of a rarity in ceramics, a full-blooded Pop artist. Slee passes every test for Pop Art citizenship, much as he fails most such tests for the crafts. His taste is for the synthetic, an approach disapproved of by the crafts, but that is the preferred look of Pop Art where the ersatz always trumps the *echt*. Like other Pop artists he is drawn to industrially made objects. Most of the ceramics he admires are the products of a factory, from the high art of court porcelains to the low art of gift shop knick-knacks.

His work has a slick, polished look (what Perry calls 'its inhuman gloss'[7]) with no sign of the hand even though they are hand-assembled from moulded elements. 'The reek of cheap slip cast giftware is washed away,' writes Perry, 'when I think that each of these pristine overscale mementoes has been laboriously finished to eradicate the evidence of human touch.' This is hardly the act of someone committed to an art rooted in process and materials. Pop studiously avoids the stamp of the handcrafted object, even though some Pop Art is superbly handcrafted. The Pop movement's taste is for processes that look as though they are about mass replication.

In this world Slee's objects live freely without the contradictions and those complex reverse arguments used to implicate him in the crafts. It is important to state at this point that this argument is not meant to be hierarchal. Drawing the lines between Pop Art and the crafts is not an exercise in giving Slee superior stature to that of ceramists who are legitimately part of the crafts. It is only about seeking a context that is appropriate in order to give his art its full voice. It does, however, make him decidedly different in his styles, methods and goals to those in the crafts.

For instance, Deacon's contention that Slee's work is about function makes little sense in craft terms but does have validity if we consider functionalism in the Oldenburgian mould. Claes Oldenburg's (b.1929) fascination with function is not the same as that of the crafts world. The crafts link daily use to a complexity of moral and political arguments that include socialism, the protestant work ethic and other issues. Finally, tying utility to handmade objects that are often somewhat esoteric and costly is a tad elitist. In Pop the utilitarian association of bicycle seats, clothes pegs, erasers and Swiss army knives gives these objects familiarity and access.

Like Oldenburg, Slee can also imbue the everyday with glamour, not the reductive, monumental, sculptural authority of Oldenburg, although there is a hint of this possibility in his art were it to be scaled up, but rather in the street pizazz of neon and Day-Glo that is closer to Andy Warhol (1928–87). There are many other connections big and small, such as an empathy between his flower and grass tableaux with Tom Wesselman's (b.1931) drawings in space cut from sheets of metal.

In the past a few writers have offered that Slee may at least have been influenced by Pop, but they have cited the pioneering British artists as the source. Pop Art began in London so it seems to fit. The first official Pop Art work is considered to be Richard Hamilton's (b.1922) collage entitled *Just What Is It That Makes Today's Home So Different, So Appealing* (1956). Even the movement's name was coined in Britain when Laurence Alloway penned his seminal 1958 essay, 'The Arts and the Mass Media' for *Architectural Digest*. But British Pop, with perhaps the exception of Patrick Caulfield (b.1936), was more literary and political than the American version, which was taken over by a group of masterful and slick style-merchants. This more stylised and iconic form soon became the dominant expression. As a 'Style-Dandy',[8] to use John Houston's characterisation, it is not surprising that Slee was more drawn to American Pop Art just as the more flamboyant American ceramics interested him more than British studio pottery.

However, Slee's place in the Pop movement is not within the 'classic' period of the first generation. Warhol, Lichtenstein (1923–97), Rosenquist (b.1933) and others were unquestionably influential in his development, but this phase of the movement was already beginning to peak when Slee encountered it as a student at the Central School in London. It is more accurate to view him as Neo-Pop. Among its more famous early exponents are Keith Haring (1958–90) and Jeff Koons (b.1955), artists who are closer to Slee's generation and mindset.

Neo-Pop is more playful, idiosyncratic and catholic than the purveyors of classic Pop, but this art does not always appear under the Neo-Pop umbrella and so it may seem less influential than it indeed is. These artists can also be found labelled as Appropriation, Neo-Dada, Neo-Geo and under the more unspecific rubric of Postmodernism. But they are all the children of the original Pop movement. It is not country specific as it once was, although in the last decade Japanese artists like Mariko Mori (b.1967), Kenji Yanobe (b.1965) and Takashi Murakami (b.1962) have brought an electric new presence to this arena, a profusion of toys, figures, robots and other objects drawn from the tradition of Japanese comics (*manga*) and animated films (*anime*) that engage in debates about technology (saviour or destroyer) and often invoke heroism and idealism expressed through the fantasy realm of super-heroes.

Slee's tastes are more Western. If one has to ally him to any particular movement or artist it would probably be with Jeff Koons, the most famous and controversial exemplar of Neo-Pop. Originally, the author was uneasy about raising this artist's name when speaking to Slee. Many ceramists see Koons as a kind of Antichrist, embodying everything that is wrong with art and its market place today. (For that matter he is viewed with distrust – and envy – by artists in all media.) But for ceramics the hostility is more personal and has to do with his 'invasion' of their field in 1988 when he created an exhibition, *Banality*, a series of larger than life porcelain figures.

Howard Kottler
45 **Waiting for Master** 1986
Simulated gold leaf and paint.
H. 97 cm; 38 in
Private collection
Photograph: Roger Schreiber

Adrien Saxe
46 **Chou Teapot with Baby and Fossil** 1992
Porcelain and mixed media.
H. 23.5 cm; 9.25 in
Private collection
Photograph: Anthony Cunha

Jeff Koons
47 **Michael Jackson and Bubbles** 1988
Ceramic.
W. 179 cm; 70.5 in
Private collection
Photograph: Sotheby's New York

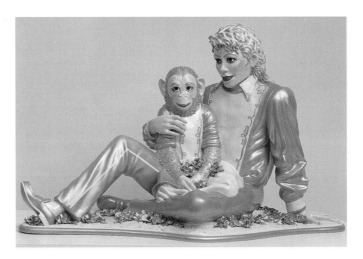

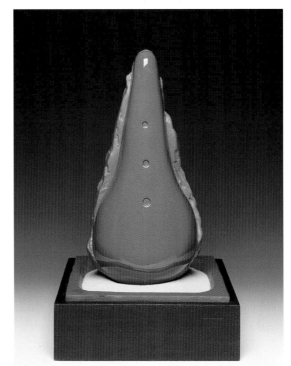

Claes Oldenburg
48 **Bicycle Seat** 1976
Porcelain, ceramic and wood.
H. 36 cm; 14 in
Private collection
Photograph: Noel Allum

When the author's paper on the marketplace was read at the 2002 IAC Conference in Athens, the appearance of Koons's work on the screen provoked hisses from the audience, the kind of theatrical response once reserved for villains in Edwardian melodramas. His porcelains raised the hackles of ceramists for many reasons but their final damning denouement was that 'he did not make the pieces himself'. When the major work of the series, *Michael Jackson and Bubbles* (1988), sold at Sotheby's in 2001 for $5.6 million, the commercial success only served to rub salt into the wound.

Slee, not surprisingly, does not share this low opinion of Koons. Indeed, the only art in his bedroom is a photograph of the world's ultimate Postmodern topiary, the 40-foot-high *Puppy* standing in front of the Guggenheim Museum in Bilbao. He enjoys the transgressive edge and icy detachment of Jeff Koons's art and his readiness to wade into the *verboten* zones of sentimentality, cuteness and even pornography.

There are many similarities in their work beginning with subjects – puppies, bunnies, consumerism – and a love of Baroque excess. (The sculptor Edward Allington (b.1951) posits Slee as a master of what he terms 'domestic baroque'.) Most of these elements were present in Slee's work from the early 1970s. So Slee is not a camp follower of Koons but a fellow-traveller. The relationship between their art is at its closest when we compare two series by these artists – *Banality* by Koons and the *Tobies* by Slee. Toby, a populist bourgeois decorative arts icon, a banality in and of itself, is the clay world's antique equivalent to the Pink Panther, Michael Jackson and the teddy bears that populate Koons's porcelain tableaux.

Both Slee and Koons play with ceramic history in their series but at different ends of the class structure. *Michael Jackson and Bubbles* connects with the figurines of court porcelain made gigantic. The subject matter, a performer and his monkey, is not new and can be found in another figurine tradition, that of the *commedia dell'arte*. But the scale of the piece is startling with a larger than life pop star reclining on an oval base. Then there is the excessive use of gold, which comments, whether deliberately or not, on the role of this precious metal in the discovery of the porcelain formula in Europe.

49 **Acid Toby** 1994

H. 48 cm; 19 in
Collection: Private collection
Photograph: Zul

Slee's toby jugs are not about the palace. They are denizens of the British working class's cottage aesthetic. Slee also increases their scale, but not into the monumentality of Koons; just enough to give these vessels a slightly bloated and exaggerated presence. Whereas Koons draws links between aristocracy and celebrity, Slee parlays his pitchers into a John Bull debate about nationalism and style while hinting at social pain anaesthetised by intoxication. Oliver Watson lauds them as table-top monuments to alcoholism, child abuse and Victorian hypocrisy. Interestingly Houston intuited this direction in Slee's work even before the *Tobies* series began, writing several years earlier: 'His user friendly aim is the loud, cheerful, boozy tradition of social entertainment and meanders through public houses and along the mantelpieces and dressers of cottages and semis (semi-detached houses).'[9]

But the author's favourite of this series by Slee is *Acid Toby* (1994). It is the least complex in terms of meaning. The face of the genial, intoxicated British Everyman has been replaced with a yellow disk containing the ubiquitous, happy face. In this work, positively vibrating with emotional insincerity, Slee infuses ceramic history, Pop, Neo-Pop and Appropriation into an extremely economical and successful expression of Postmodernism. It is unquestionably his masterpiece of understatement. It is destined, Perry notes, for a different kind of cottage, those that 'are occupied as second homes or by internet workers with paperless offices in loft conversions'.[10]

As for Slee being a potter, that is a more complicated issue. It all depends upon how you define the word 'potter'. If it is used as a catch-all to describe anyone who works with fired clay, then arguably Slee is a potter. But there is already a perfectly good word for that purpose, 'ceramist'. Potter is more specific. It suggests a maker of pots and that is how the author has always used the word. At one point Slee, with deliberate provocation moved the label several notches further to the right of the crafts when he announced that he was not just a potter but a 'crafts' potter. The term is ripe with images of earnest makers, wearing pleated smocks, contentedly seated at the wheel in a converted fifteenth-century stone mill house, throwing on the hump with rows of glistening wet, newly formed vessels lined up

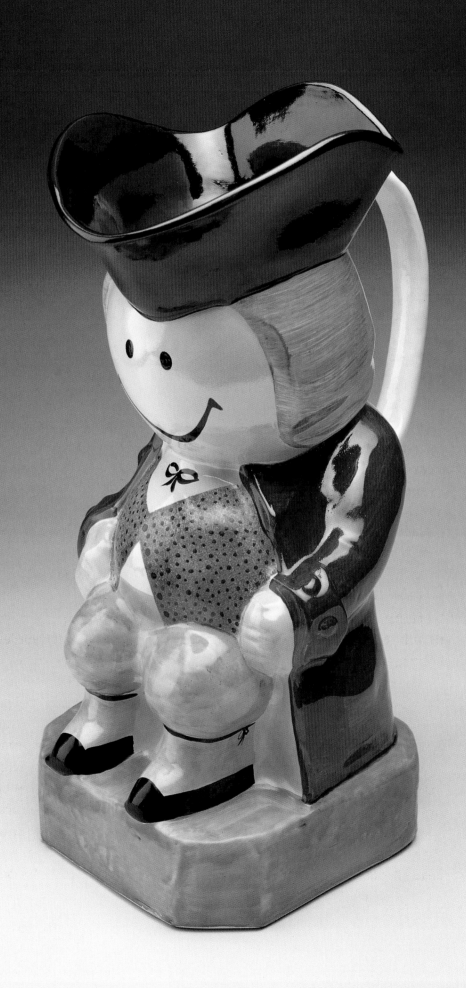

behind them on shelves. If you then take that snapshot and place it alongside Slee's art, it creates immediate dissonance, and he enjoys this mischief.

But even if we get away from the cliché of rustic pottery and examine his claim to potter-hood in the setting of a smart, chic, urban potter, it still does not fit. 'Why not', one may ask, 'doesn't Slee make pots?' Yes he does, but they are not potter's pots. Nor is the vessel his sole format. He is as likely to make cats, dogs and bunnies or, as Perry describes it, 'the crude clash of pets and pots'.[11] He also makes houses, brooms and closed abstract biomorphic forms to which one cannot attach any label. Slee is a sculptor and so, when he makes pots, they are a sculptor's pot. It is important, because potter's skins have thinned after years of friction with the fine arts in trying to legitimise their art, to emphasise once more that this nomenclature does not imply any inherent superiority. Both a sculptor and a potter can be an artist. The words signal a difference of kind and not of class.

Slee may well contradict me, but he does not approach the vessel in the same way as a studio potter. All you have to do is place one of his pots next to a vessel by Hans Coper (1920–81), Lucie Rie (1902–95), Elizabeth Frisch (b.1940) or Alison Britton (b.1948). They are simply not about the same aesthetic journey even if they get shown at the same destinations. Potter's pots are made from the inside out. For the greater part they are about a holistic interior abstract power that comes through the manipulation of volume and the vibrato of inner and outer space. 'He is not hypnotised by the finger-licking perfections (and flagrantly flaunted imperfections)', Houston adds, 'of the pots for pot's sake aesthetes'.[12]

Sculptor's pots are different in that they are used as identifiable icons to evoke domestic identity, to enlist decorative associations, to connect with cultural periods or styles but not to engage the vessel as a vehicle of the sublime. Slee's pots are charming, quirky and pixie-ish but they do not engage the language of the vessel so much as they use what a pot *means* culturally. Nor do his pots evince conversations about the lift from foot to belly, or the proportional poetry of the neck and lip, or even some hymnal celebration of fire, clay

and process. The hand that guides them into life is less that of the potter and more that of the illustrator.

Much of Pop Art, both two- and three-dimensional, is rooted in illustration, its techniques, visual devices and association with commercial art. In objects this results in shape being more important than form. Slee tends to outline the shape of his forms with a white line where the glaze breaks on clay seams as though he is drawing over the form. But this does not mean that Slee lacks a sense of form. On the contrary, his sense of form is both powerful and original with a distinctive, soft, plumpness that one associates with inflated toys, complete with the sharp edges that remind us of the plastic seam-marks where the elements of the form are heat-fused together.

Indeed we could go a step further and suggest that Slee creates something approaching a caricature or cartoon of the vessels. It would not take much to transfer one of his pots from their three-dimensional reality into the two-dimensional landscape of an animated film. This can be seen in *Standing Plate* (1986), which has a beautiful edge drawn with the meandering cursive line of a rough pencil sketch. The well of the plate sports a faux shadow painted by the artist, much the same conceit that Roy Lichtenstein (1923–97) used in his cup sculptures of the 1960s and his plates and other ceramic productions thereafter. The plate is not allowed to function at all except as a decoration. This is determined by a built-in stand formed with Slee's signature organic textural surface. This means that the plate has to be frontal, upright and read in silhouette. The bland glazing of the back of the plate instructs us that it is of no consequence.

While we may quibble about Slee being a potter, ceramist or sculptor, what is not in doubt is his love of ceramics and its millennia of cultural detritus, a parade through Western culture, transversing time, style, fashion, function and ritual. Slee is steeped in the 'stuff' of ceramic history, '... the colossal presence of pottery past: eight thousand years of ceramic wares; often representing the best of society's technical, intellectual and emotional

## 50 **Standing Plate** 1986
H. 36 cm; 14 in
Private collection
Photograph: Noel Allum

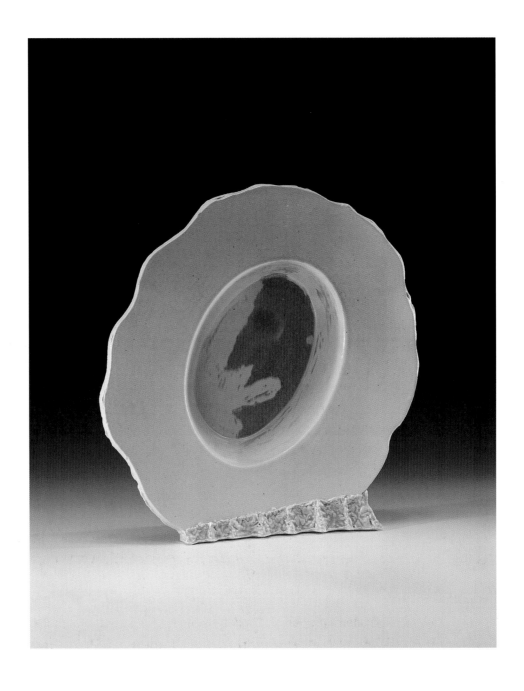

capabilities'.[13] It pulsates through his work and gives it the integrity, authority and
eloquence of an informed, passionate and refined taste.

This information is never presented in the manner of an antiquarian, nor through excessive technique that mimics the past. It is mostly introduced through nuances, sleight of hand, humour, parody and, even though this is the most overused word in art today, irony. One has to agree with Houston's contention that 'Slee is not nostalgic about old forms; past life is visible in things but there is no doubt that it is the life he relishes. His affections are for the awkward squad ... particularly those artifacts that are congenitally out of step with prevailing trends.'[14]

Given Slee's love of ceramic history, and in particular British pottery, it is interesting that his work does not fit well with British studio pottery. There is always Carol McNicoll who is regularly cited as a kind of Siamese twin to Slee. But aside from both being talented iconoclasts, the parallels drawn between their ceramics are superficial and misleading. They are travelling two very different paths. Slee occasionally makes asides about this important movement but it is not a central part of his content or style. American ceramics is a stronger influence even though, paradoxically, American ceramists see him as being very British in his approach.

Slee's strongest early influence was Ken Price (b.1935), one of America's greatest ceramists, also an outsider to the crafts but, unlike Slee, one who vigorously defended his distance. Slee remembers seeing Price's architectural cups – works of pure and startling genius that Price showed in London in the early 1970s at the Kasmin Gallery. These immaculately crafted objects with their singing, primary palette were remarkable, witty, planar studies into the spatial milieu that an object can occupy.

They derived from Price's roots in Fetish-Finish, a Southern California art movement of the 1960s that attracted a wide range of painters and sculptors including Pop artist Ed Ruscha

(b.1937). The work was defined, as the title suggests, by its meticulous, obsessive finish, often drawn from industrial models such as automobiles and involving new materials like fibreglass and automotive lacquers, the latter often used by Price to replace glaze, a heretical act in its day. Raised in an environment of both touchy-feely, earth-coloured organic abstraction and the truth-to-materials rusticity of the Leach school, these objects were revelations to Slee.

There are several other Americans who work in manner similar to Slee, from the pioneering Howard Kottler (1930–89), an Appropiationist in the 1960s before the term was even invented, to the Pop-Abstractionist, Ron Nagle (b.1939) with his air brushed, china-painted cups and the overly luxurious bibelots of Adrian Saxe (b.1943), drenched in gold glazes and studded with fake gems.

But it was not just the high art that inspired Slee. During a visit to the United States in 1974 he stayed with a couple who collected 1930s and 1940s ceramics, mainly Californian but also the work of Hall and Company, from East Liverpool, Ohio. This factory made 'refrigerator' ceramics, so named because they were mainly made as water pitchers for the booming new market in this kitchen appliance. The pitchers were commissioned by factories like Westinghouse and given out as premiums and awards to buyers of new fridges. They are simple, inexpensive but stylish forms made in two-part moulds, undecorated and with monochrome glazes. From these objects Slee learnt something immutable about the balance of style and economy that left an indelible imprint on his art.

Slee described them in 1991 as 'fat, clumsy pottery: a new kind of scale and proportion for me ... The glazes were primary and pastel colours, and some of the forms were streamlined "Aerodynamic" style which fitted my affection for the Disney animation influence.'[15] From these objects Slee either learnt or recognised something already inherent in his art about the power of this austere blend of style and economy. In this interview he also comments with an edge of respect as a style-meister himself 'that they were designed by people who

51 **Water Pitcher** 1940
Hall and Company,
made for Westinghouse
Earthenware
H. 23 cm; 9 in
Collection: the Artist
Photograph: Noel Allum

Kenneth Price
52 **Untitled Cup** 1974
Ceramic
H. 10 cm; 4 in
Private collection
Photograph: Ceramic Arts Foundation

53 Collection of California and
refrigerator ceramics, USA
1974
Private collection
Photograph: Richard Slee

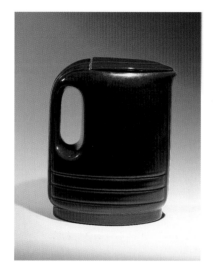

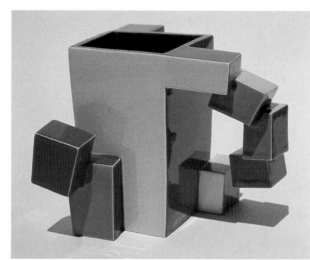

were obviously much more interested in styling than in ceramics or any tradition in ceramics'. For an artist for whom style is God, this freedom must have been tempting.

Finally, turning to the objects themselves. They are much more friendly, informal and direct than the contentious contextual basis of Slee's art would suggest. In particular they have a quiet humility, not the artificial variety one finds in contemporary rustic pots, but something more inherent and more genuine. Also there is not the P. T. Barnum quality of technical tours de force and flash that one finds in the work of Koons and some other Neo-Pop artists. It is partly this total absence of pretension that makes their charm so irresistible. Writers frequently speak of them as 'decorative' and 'ornamental'. They certainly seem decorative from a distance but the closer one gets to the objects the less decorative they become and when one is a couple of feet away a tough reductivism takes over. One is always a little taken aback at how elemental and understated these objects are when viewed from close proximity. It is as though a painting one identifies from a distance as Frank Stella morphs into an Ellsworth Kelly when confronted face-to-face. It is a remarkable effect, both eerie and powerful.

While Allington is correct in saying that Slee has a Baroque sensibility (or maybe Perry's description of it being 'the fifth hand rococo of kitsch'[16] is more precise), Slee has pared down the exuberance of this influence into a statement of surprising quietude and repose. In some ways one is reminded of another master of Neo-Baroque, Lucio Fontana (1899–1968), and his ability to eventually render that style down to three knife cuts against a flat red canvas and yet retain its spirit.

Then there is another aspect, that for all the optimistic colour and sense of play that Slee's work projects there is an almost imperceptible tinge of isolation, melancholy or pathos, which, like the visual toughness and almost astringent economy, is not what one expects. This has long been a private musing, but in Grayson Perry's essay for Slee's solo show at Barrett Marsden in 2000 it was intriguing to read that he detected the same mood, noting

that 'All this elegant perceptual fun is shot through with a sad twinkle of loneliness. The lighthouse isolated on the frozen wave, a boy's game on a rug suspended in time.' Could this come from decades of being craft's resident alien, or does it say something about Slee's childhood? At this time the source of this sensibility is not material but its impact is. It gives his art a genuine tenderness, a heartbeat under the surface of glassy style that is neither mawkish nor sentimental but connects these objects to life in a deeper way than much of the work of this genre.

54 **Brooms** 1998
With bamboo
H. 250 cm; 97.5 in
Collection: the Artist
Photograph: Zul

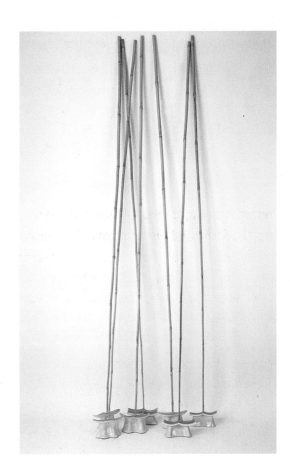

55 **Swell** 2000
With addition
L. 55 cm; 21.75 in
Collection: Tim Burne
Photograph: Philip Sayer

56 **Sailor Cat** 2000
H. 44 cm; 17.5 in
Private collection
Photograph: Philip Sayer

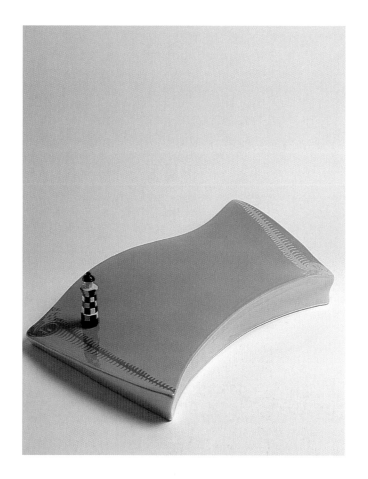

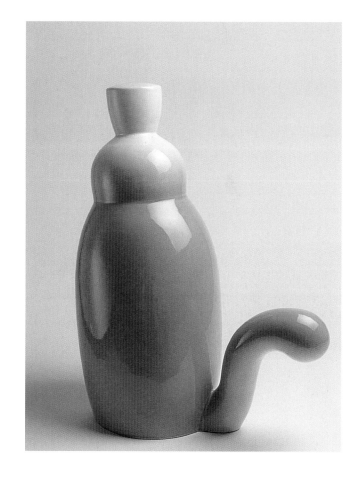

Ron Nagle
57 **Son of Slim** 2001
Overglazed earthenware
H. 15.5 cm; 6 in
Private collection
Photograph: Don Tuttle

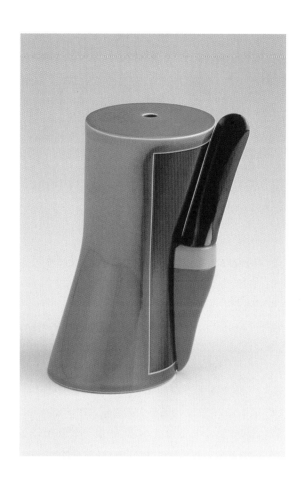

58 **Blue Plane** 2001
On felt base
H. 33 cm; 13 in
Private collection
Photograph: Philip Sayer

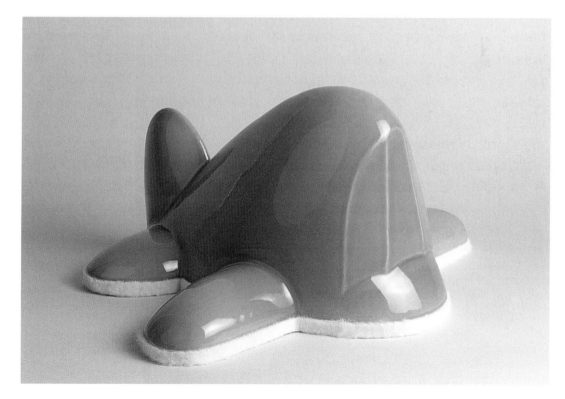

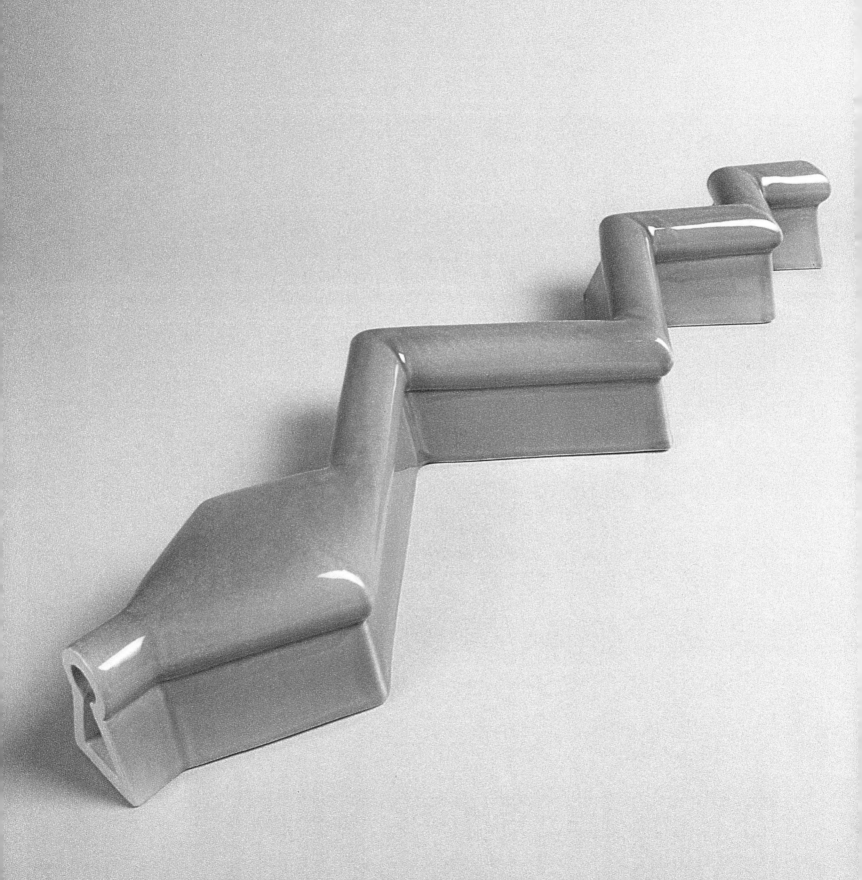

59 **Domestic Keyhole Snake**
2001
L. 63.5 cm; 25 in
Private collection
Photograph: Philip Sayer

Finally, a departing image for this essay might well be that of a purple snake, a long skinny sculpture by Slee, shown at the Barrett Marsden's group summer show in 2001. The reptilian quality was removed and replaced with cool abstraction. The snake was also defanged, both figuratively and literally, its usually venomous jaw replaced with a keyhole. This provoked a riddle or paradox in which the answer was unimportant but the question, 'what key and what door' was alluring.

But as it zig-zagged its way across the floor with a mechanical, geometric precision it brought to mind a comment that the writer and critic Carter Radcliff made about the art of Andy Warhol and which seems to sum up the evasive 'now-you-see-it, now-you-don't' quality in Slee's objects. Radcliff writes that Pop Art is about a way of seeing and engaging contemporary life from the vantage point of street level, where 'the image-traffic is always jammed. The meanings of [this] art appear at tense intervals, through the gaps in the culture's shifting surfaces.'[17] So too, with the ceramics of Richard Slee.

# Notes

1  John Houston, 'Richard Slee', *Ceramic Series 46*, March 1991 (unpaginated).

2  Richard Deacon, *Richard Slee/Katherine Virgils*, exh.cat., British Crafts Centre, London, 1984.

3  Oliver Watson, *Richard Slee: Grand Wizard of Studio Ceramics*, exh.cat., Barrett Marsden Gallery, London, 1998.

4  Grayson Perry, *Richard Slee*, exh.cat., Barrett Marsden Gallery, London, 2000 (unpaginated).

5  Watson, ibid.

6  Perry, ibid.

7  Perry, ibid.

8  Houston, ibid.

9  Houston, ibid.

10  Perry, ibid.

11  Perry, ibid.

12  Houston, ibid.

13  Houston, ibid.

14  Houston, ibid.

15  Houston, ibid.

16  Perry, ibid.

17  Carter Radcliff, 'The work of Roy Lichtenstein in the age of Walter Benjamin's and Jean Baudrillard's popularity', *Art in America*, vol.77, no.2, February 1989, p.112.

Selected works

60 **Plate** 1970
Diam. 27 cm; 10.5 in
Collection: Jeffery Pine
Photograph: Zul

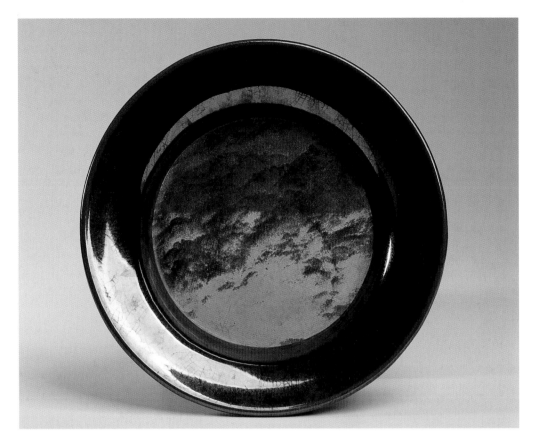

61 **Three-part Jug** 1977
H. 21.5 cm; 8.5 in
Collection: Jeffery Pine
Photograph: Zul

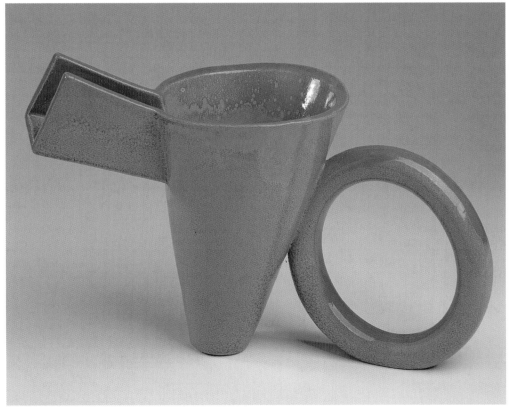

62 **Jug** 1977
H. 25.3 cm; 10 in
Collection: Jeffery Pine
Photograph: Zul

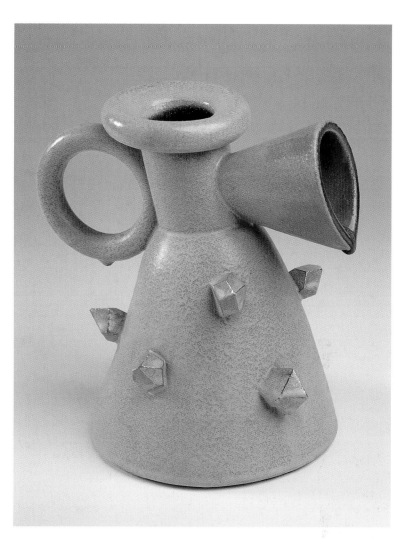

63 **Dog Dish** 1977
W. 17 cm; 6.75 in
Collection: Jeffery Pine
Photograph: Zul

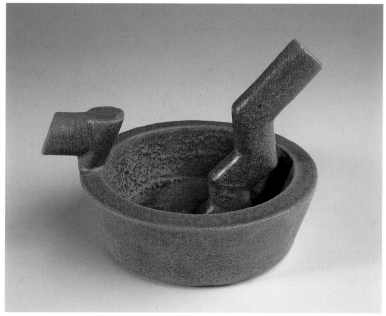

64 **Ring Tray** 1972
H. 19.5 cm; 7.75 in
Collection: Jeffery Pine
Photograph: Zul

opposite
65 **Teapot** 1980
H. 36 cm; 14.5 in
Collection: the Artist
Photograph: Zul

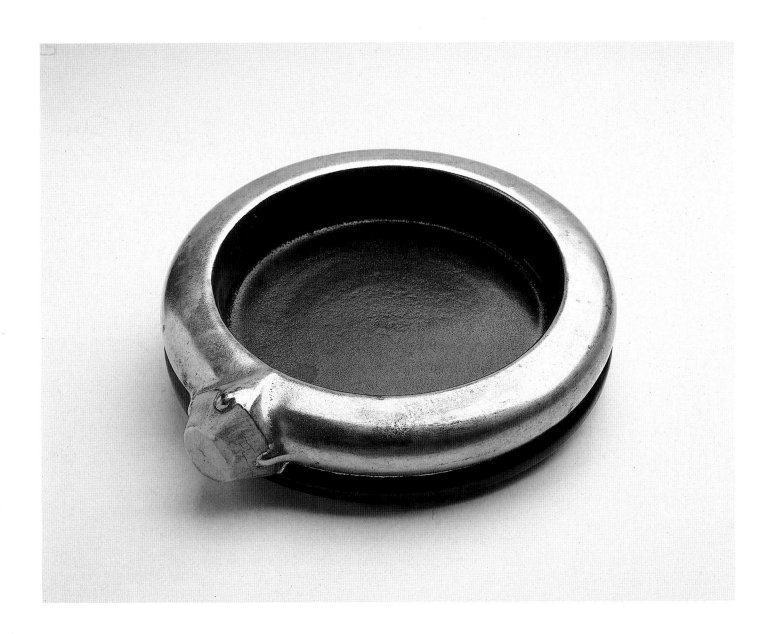

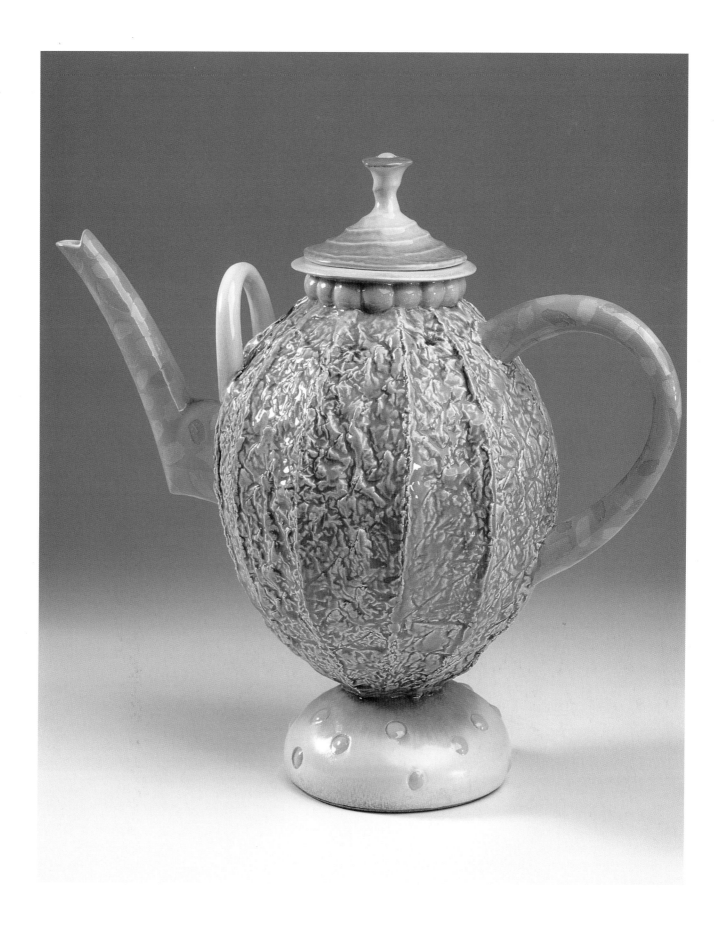

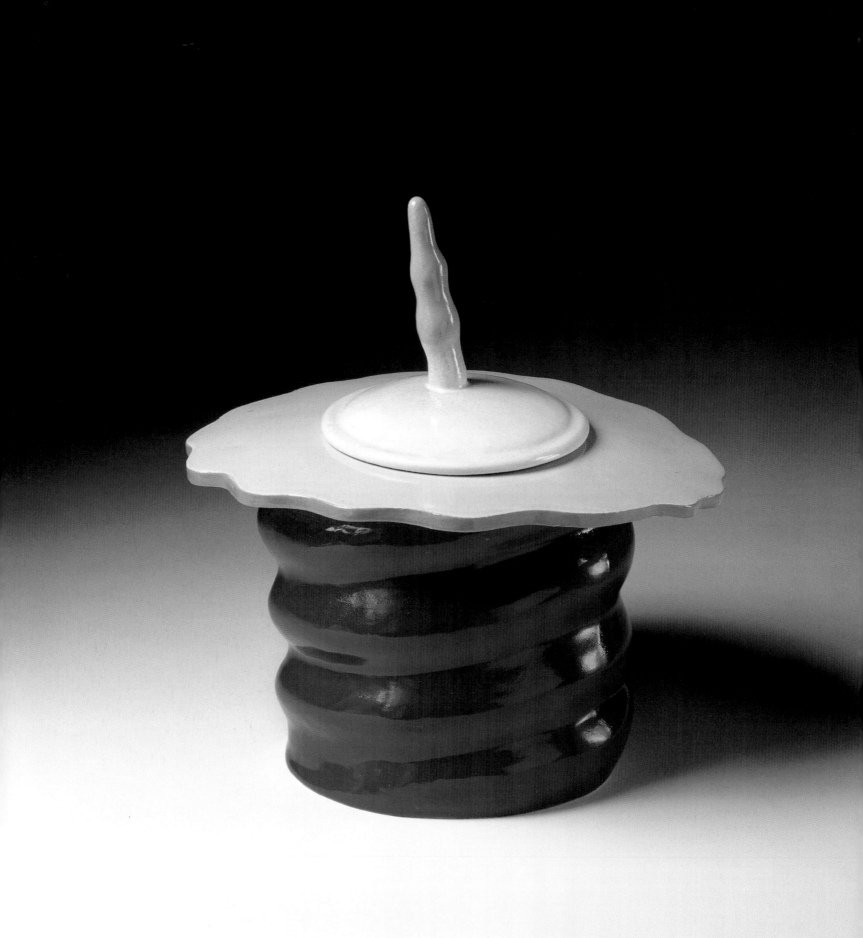

opposite
66 **Jar and Cover** 1981
H 26.8 cm; 10.5 in
Collection: Victoria
and Albert Museum, London
Photograph: Victoria
and Albert Museum
© V&A Images

67 **Coral Dish** 1984
Diam. 34.9 cm; 13.8 in
Collection: Victoria
and Albert Museum, London
Photograph: Victoria
and Albert Museum
© V&A Images

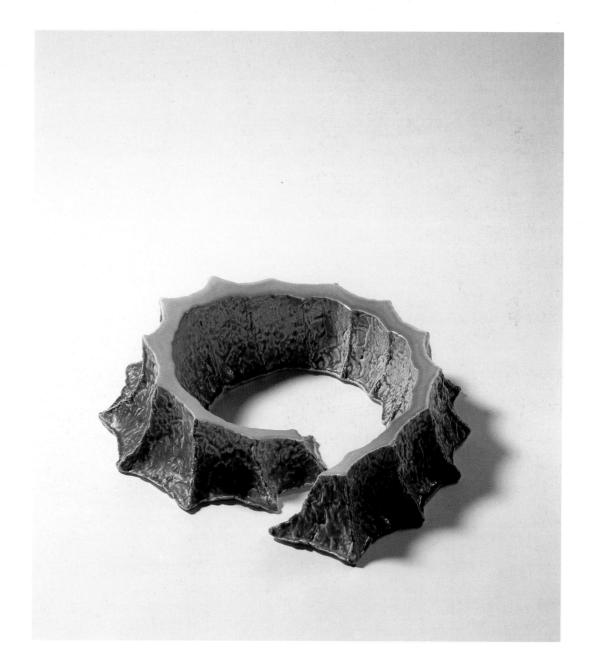

opposite
69 **Tripod Vase** 1982
H. 40 cm; 15.75 in
Collection: Jeffery Pine
Photograph: Zul

**84**   68 **Pierced Vase** 1981
H. 25 cm; 9.75 in
Collection: the Artist
Photograph: Zul

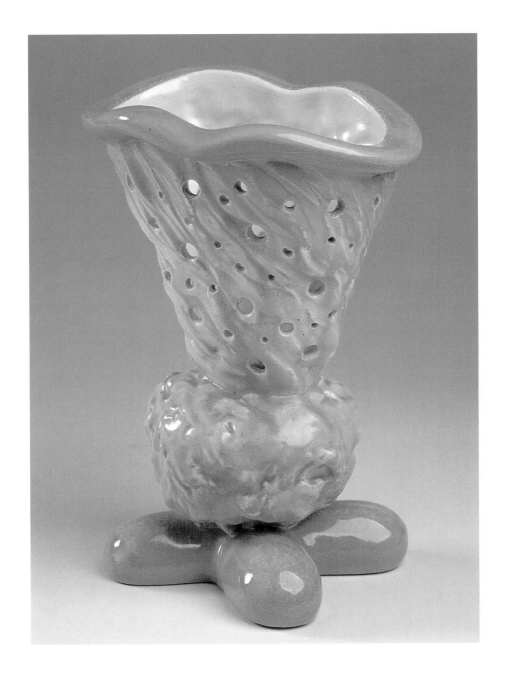

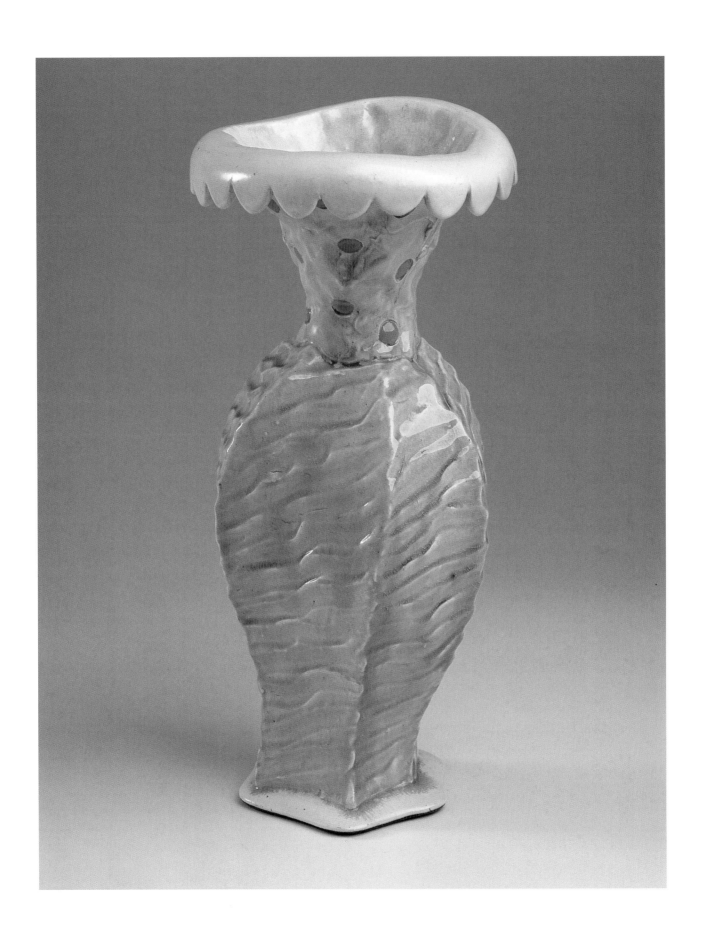

70  **Segmented Vase**  1982
H. 35 cm; 13.75 in
Collection: Jeffery Pine
Photograph: Zul

71  **Portcullis Bowl**  1984
H. 20 cm; 8 in
Collection: Jeffery Pine
Photograph: Zul

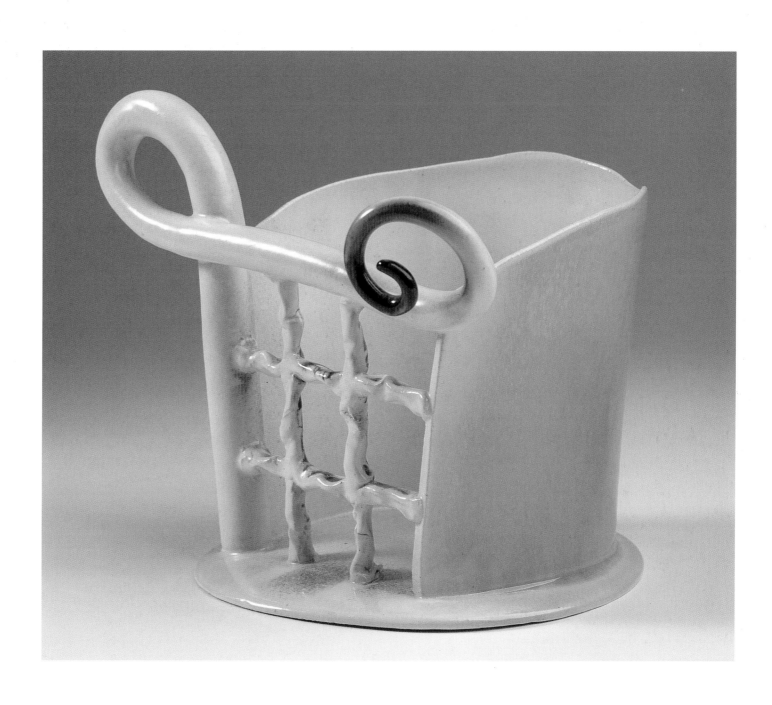

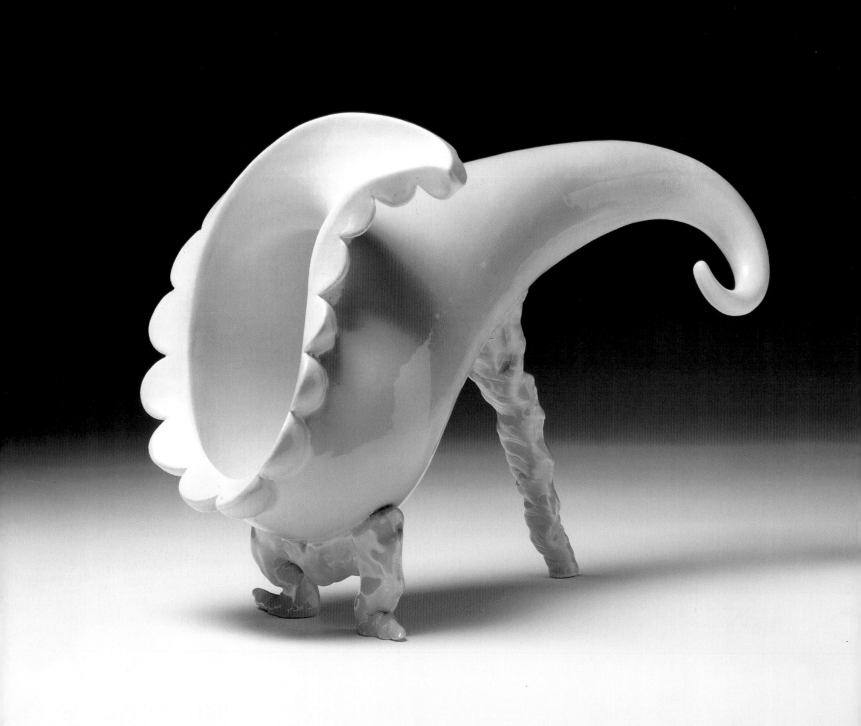

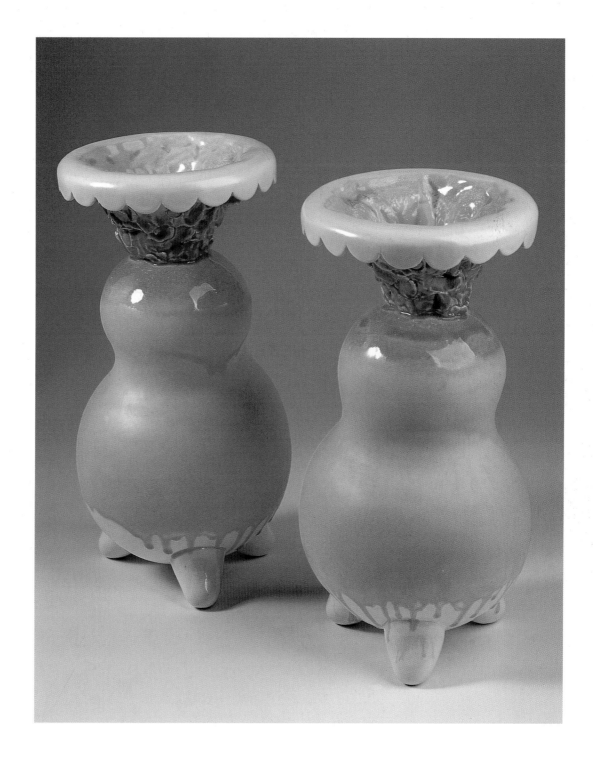

opposite

72 **Cornucopia** 1983
H 23.4 cm; 9.3 in
Collection: Victoria
and Albert Museum, London
Photograph: Victoria
and Albert Museum
© V&A Images

73 **Pear** 1984
H. 35 cm; 13.75 in
Collection: the Artist
Photograph: Zul

74 **Long Dish** 1984
L. 45 cm; 17.75 in
Collection: the Artist
Photograph: Zul

opposite
75 **Last Cornucopia** 1984
H. 38 cm; 15 in
Collection: the Artist
Photograph: Zul

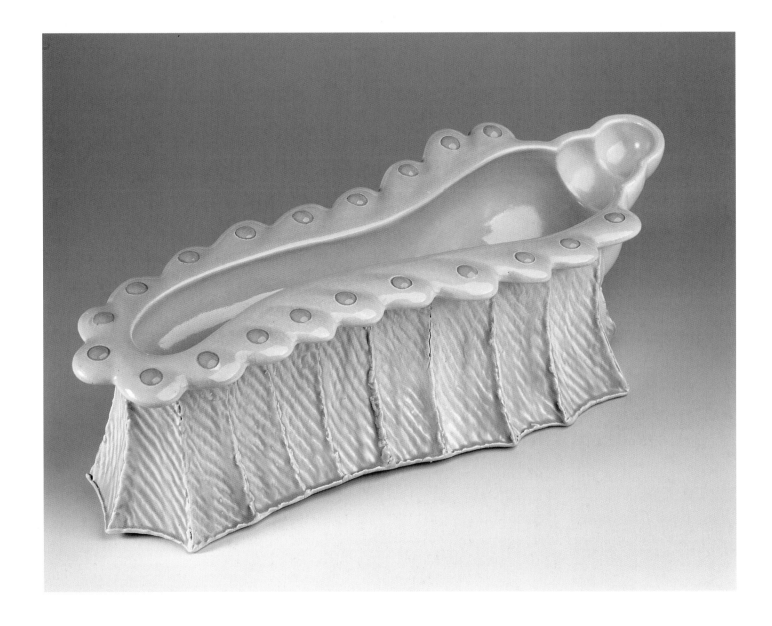

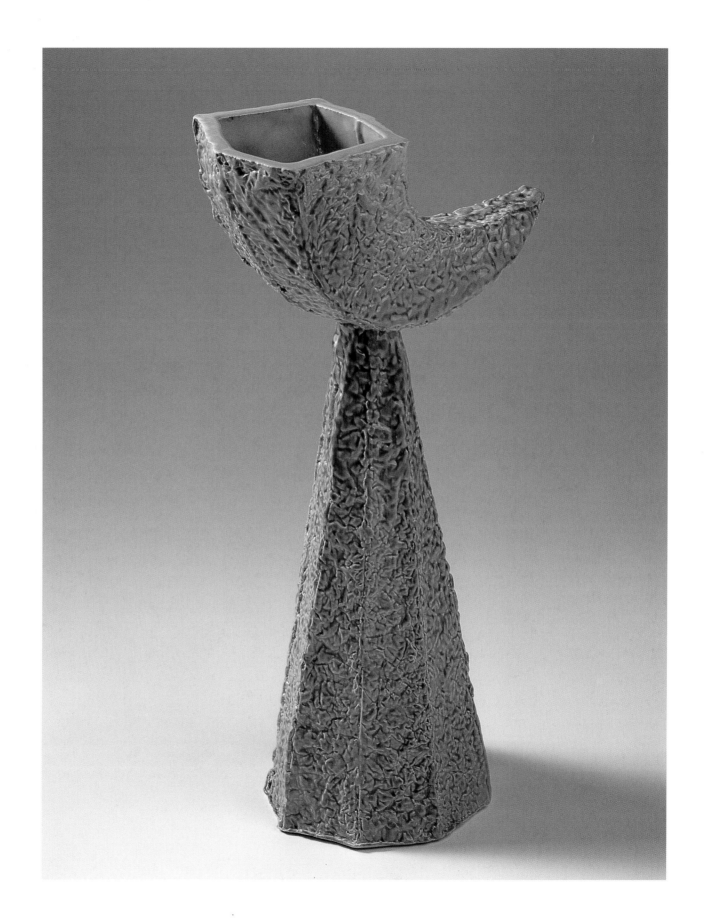

76 **Cornucopia** 1984
H. 28 cm; 11 in
Private collection
Photograph: Zul

77 **Computer Goblet** 1986
L. 23 cm; 9 in
Collection: the Artist
Photograph: Zul

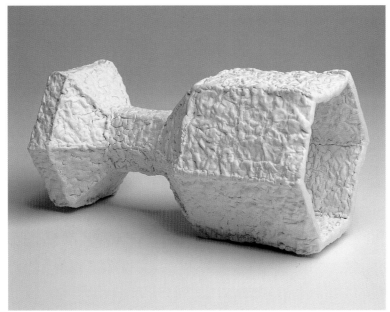

78 **Crown** 1986
H. 55 cm; 21.75 in
Private collection
Photograph: Zul

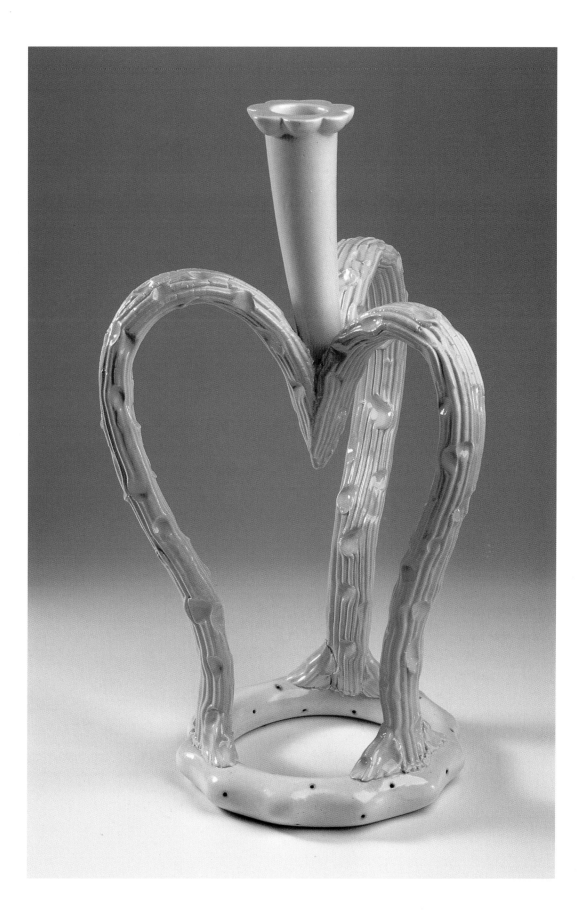

79 **Heart Dish** 1986
L. 40 cm; 15.75 in
Private collection
Photograph: Zul

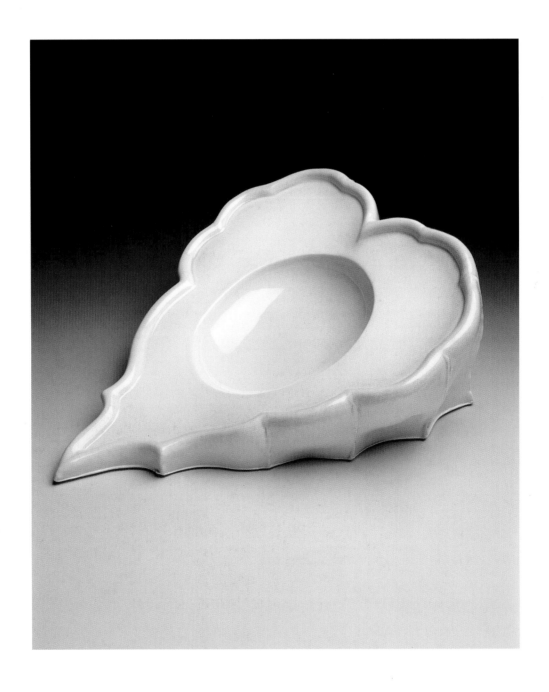

80 **Scissors** 1987
H. 23 cm; 9 in
Collection: the Artist
Photograph: Zul

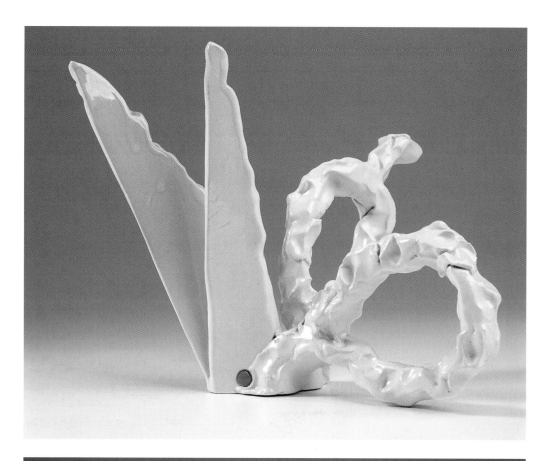

81 **Sheath** 1988
L. 58 cm; 22.75 in
Collection: the Artist
Photograph: Zul

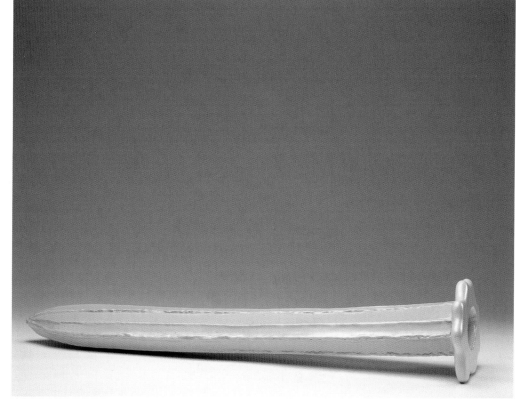

82 **Short Measure** 1988
L. 62 cm; 24.5 in
Collection: the Artist
Photograph: Zul

83 **Vase** 1989
H. 35 cm; 13.75 in
Collection: Zul
Photograph: Zul

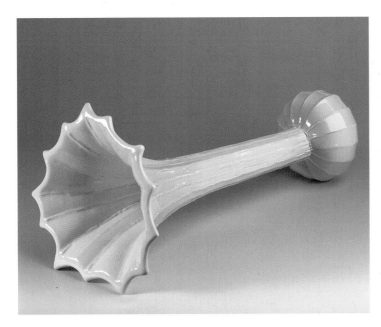

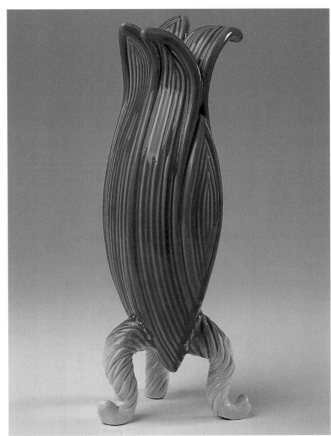

84 **Three Flasks** 1989
H 31 cm; 12 in
Private collection
Photograph: Zul

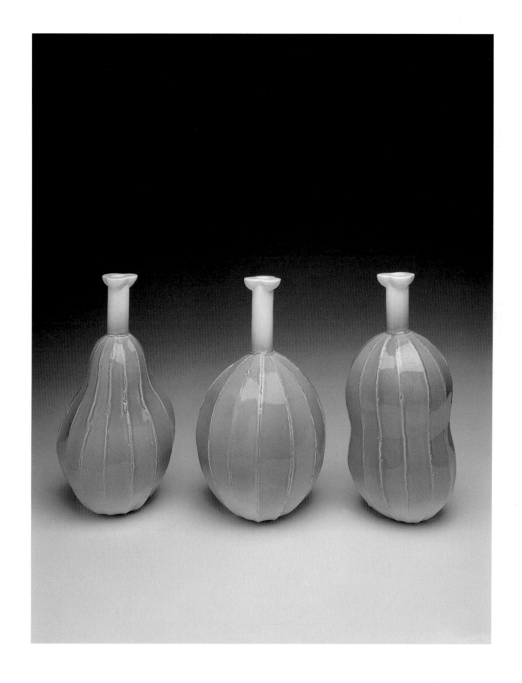

85 **Pair of Dishes** 1990
W. 24 cm; 9.5 in
Collection: the Artist
Photograph: Zul

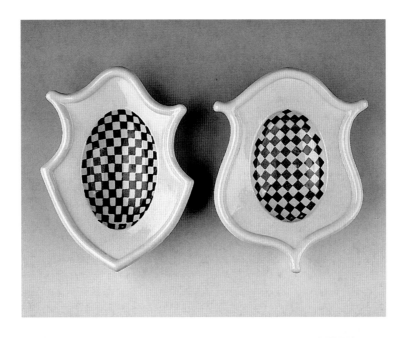

86 **Pig Dish** 1990
W. 40 cm; 15.75 in
Private collection
Photograph: Zul

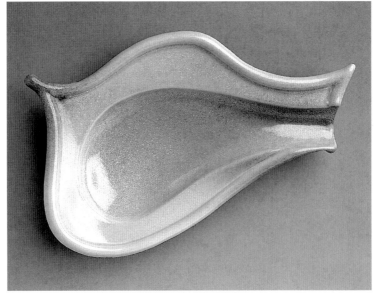

87 **Thorn and Stump** 1990
H. 44 cm, 17.5 in and 40 cm, 15.75 in
Collection: the Artist
Photograph: Zul

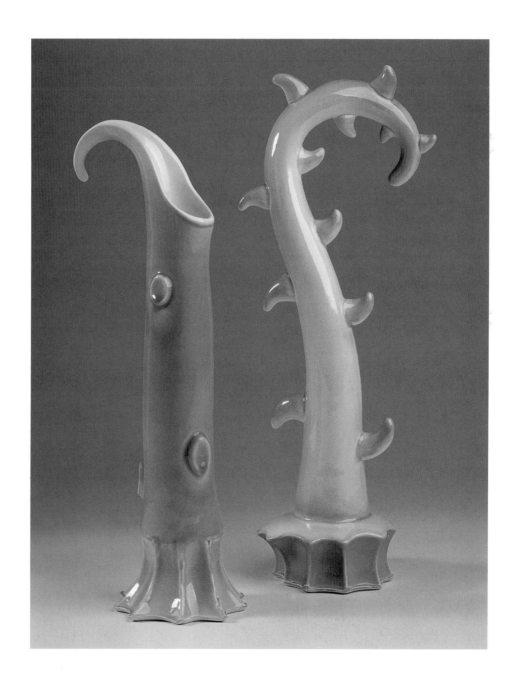

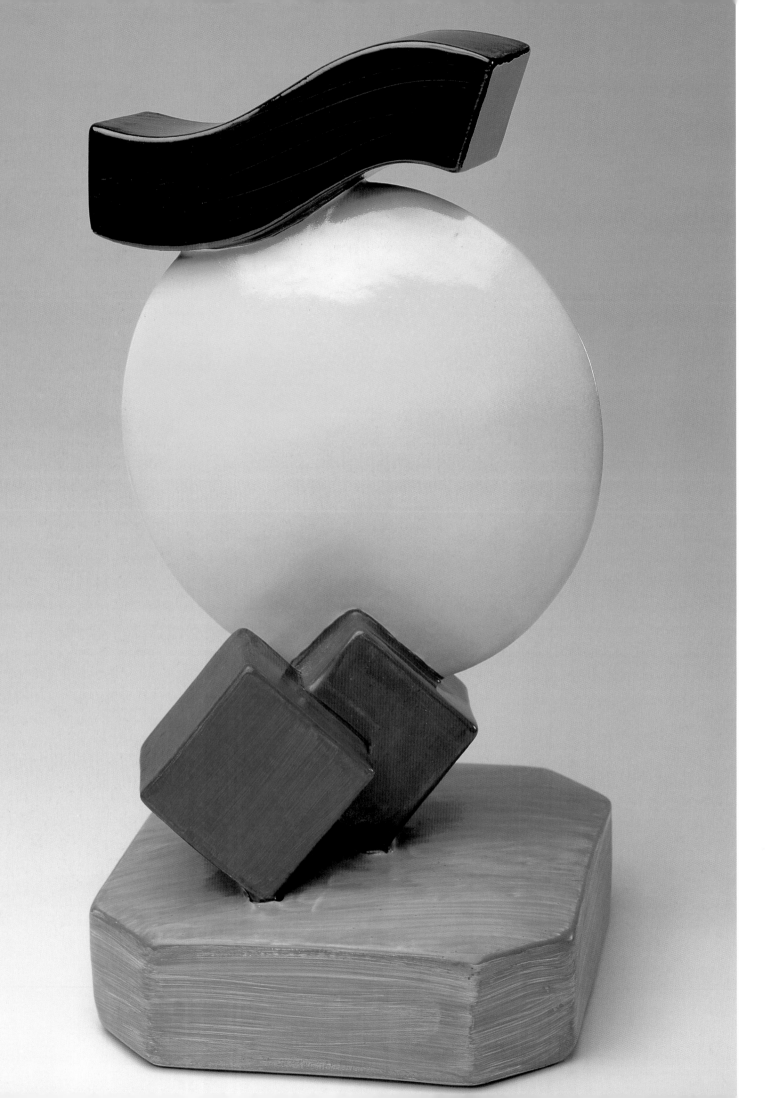

opposite

88 **Toby as Abstraction** 1994
H. 39 cm; 15.25 in
Private collection
Photograph: Zul

89 **Fuzzy Toby** 1994
H. 42 cm; 16.5 in
Collection: the Artist
Photograph: Zul

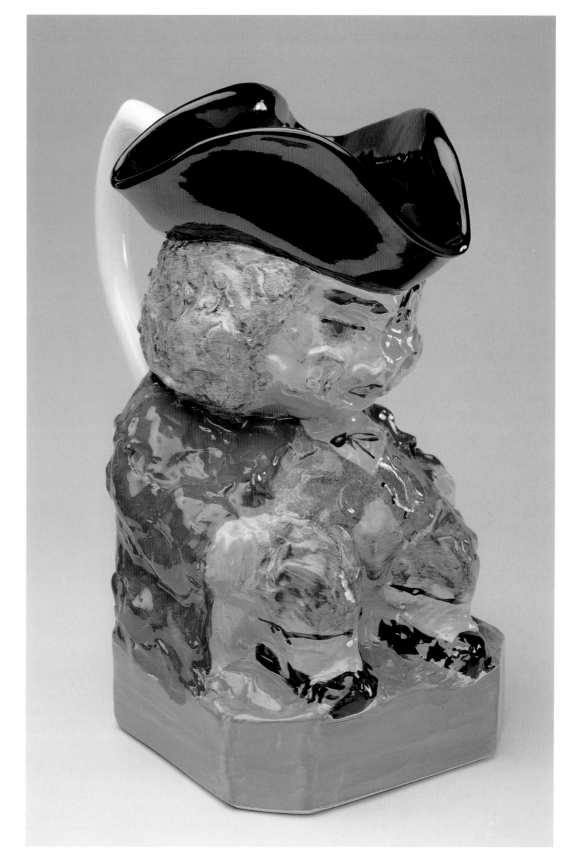

90 **Black Flag Dish** 1990
W. 26.5 cm; 10.5 in
Collection: the Artist
Photograph: Zul

opposite
91 **Jar** 1997
H. 50 cm; 19.75 in
Collection: the Artist
Photograph: Zul

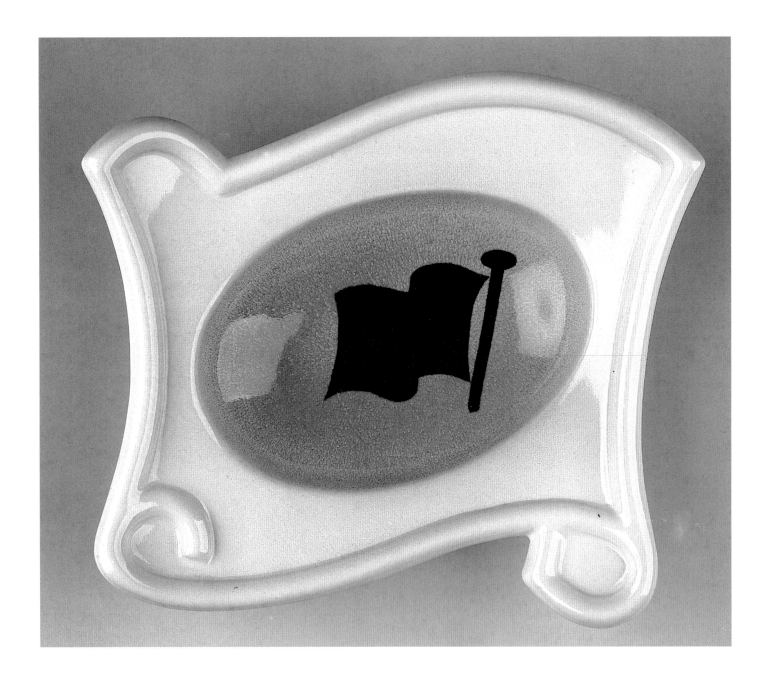

92 **Boy in Field** 1997
With addition
H. 24 cm; 9.5 in
Collection: Private collection
Photograph: Zul

93 **Horses** 1997
With additions
H. 29 cm; 11.5 in
Collection: Crafts Council, London
Photograph: Zul

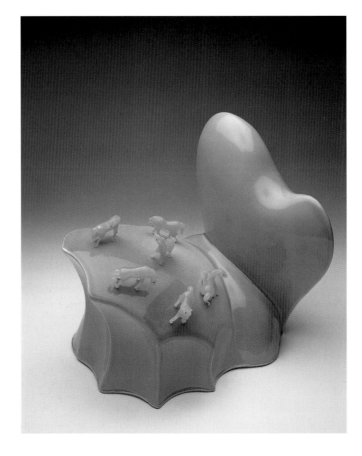

94 **Surfing Heart** 1998
With addition
L. 37 cm; 14.5 in
Private collection
Photograph: Philip Sayer

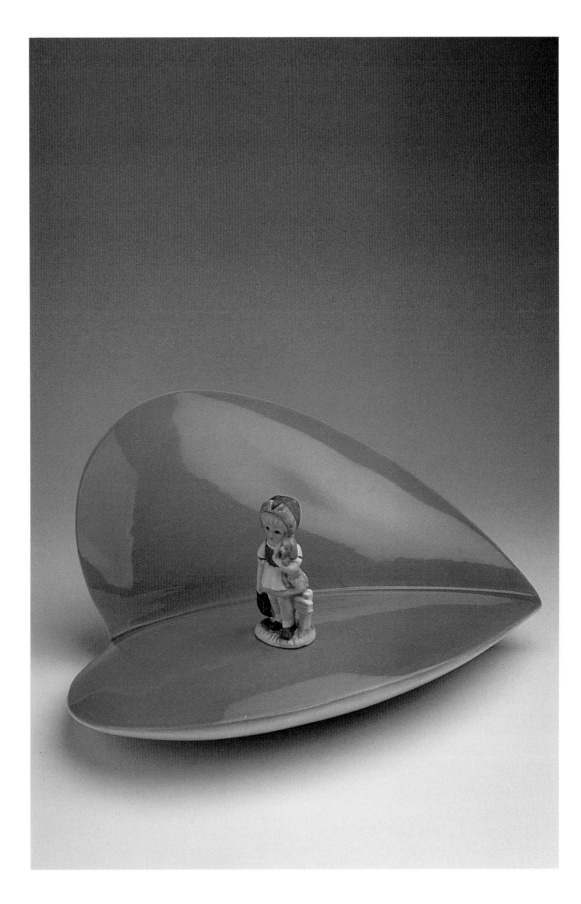

95 **Dish on Fire** 1998
Diam. 46 cm; 18 in
Private collection
Photograph: Zul

96 **Picnic** 1999
With additions
H. 26 cm; 10.25 in
Private collection
Photograph: Zul

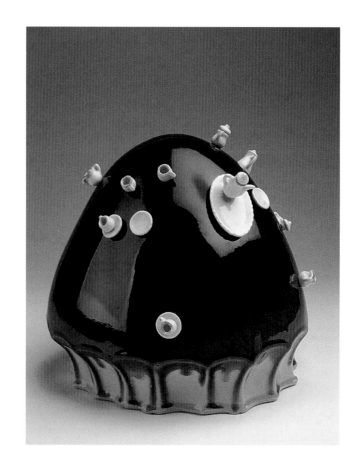

97 **Rose Twig** 2000
With addition
L. 67 cm; 26.5 in
Collection: The Potteries Museum
& Art Gallery, Stoke-on-Trent
Purchased by the Contemporary
Art Society Special Collection
Scheme with funds from the
Arts Council Lottery, 2001
Photograph: Philip Sayer

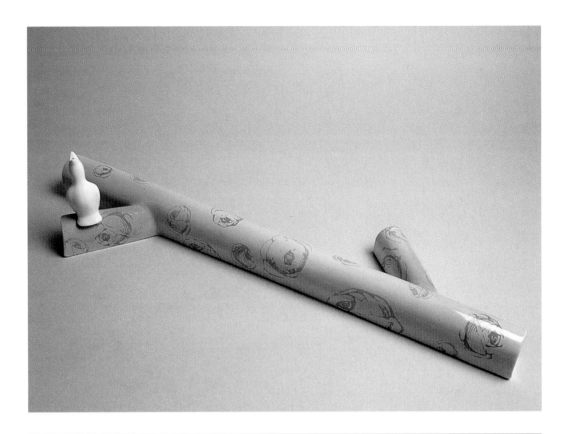

98 **Swuck** 2000
W. 46 cm; 18 in
Private collection
Photograph: Zul

99 **Tower** 2000
H. 104 cm; 41 in
Private collection
Photograph: Philip Sayer

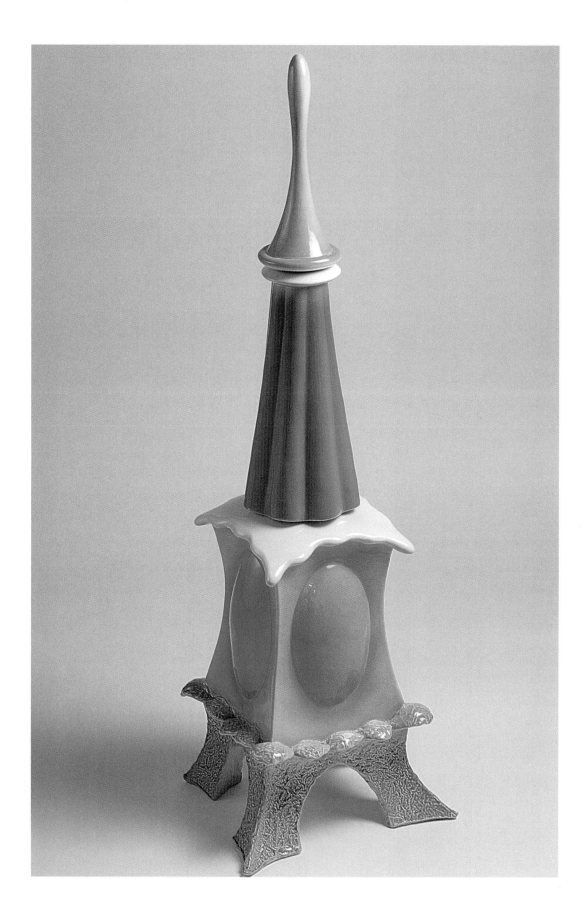

100 **Missed** 2000
L. 46 cm; 18 in
Collection: the Artist
Photograph: Philip Sayer

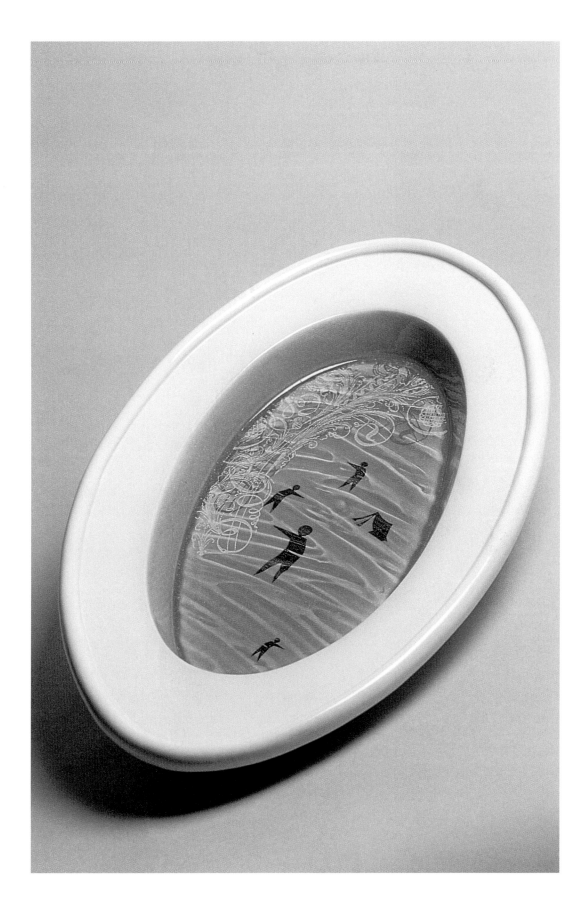

opposite
101 **Blanket Bay** 2000
With additions
13 parts; 1 m²; 3 ft 3 in² variable
Collection: the Artist
Photograph: Zul

102 **Tents!** 2001
H. 15 cm; 6 in tallest
Private collection
Photograph: Philip Sayer

103 **Vase with Ears** 2001
H 42 cm; 16.5 in
Collection: the Artist
Photograph: Zul

104 **Block Plane** 2001
L. 45 cm; 18 in
Private collection
Photograph: Guy Evans

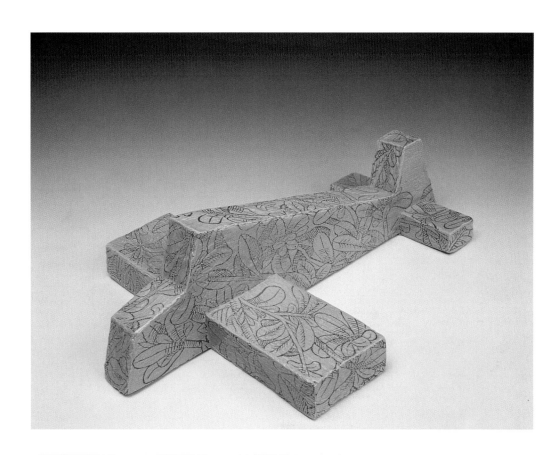

105 **Embarkation** 2001
With additions
1 m²; 3.25 ft² variable
Private collection
Photograph: Zul

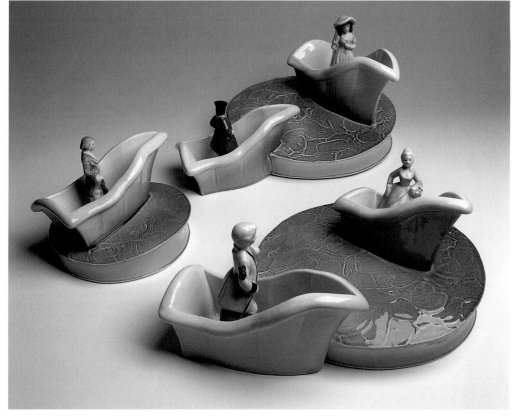

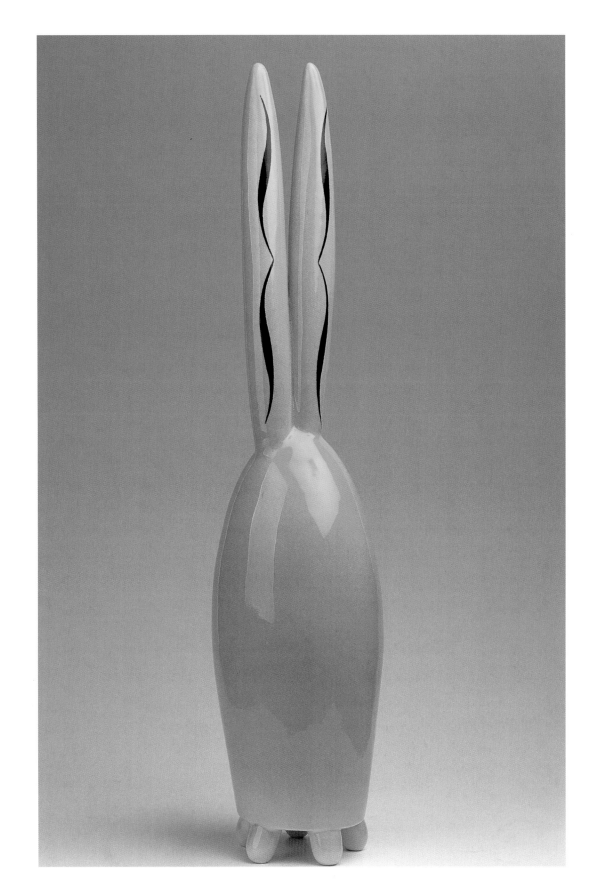

114   106  **Bracketed Rabbit**  2002
      H. 60 cm; 23.5 in
      Private collection
      Photograph: Zul

opposite
107  **Modern Friends**  2002
     With polythene tube
     H. 56 cm; 22 in tallest
     Collection: the Artist
     Photograph: Zul

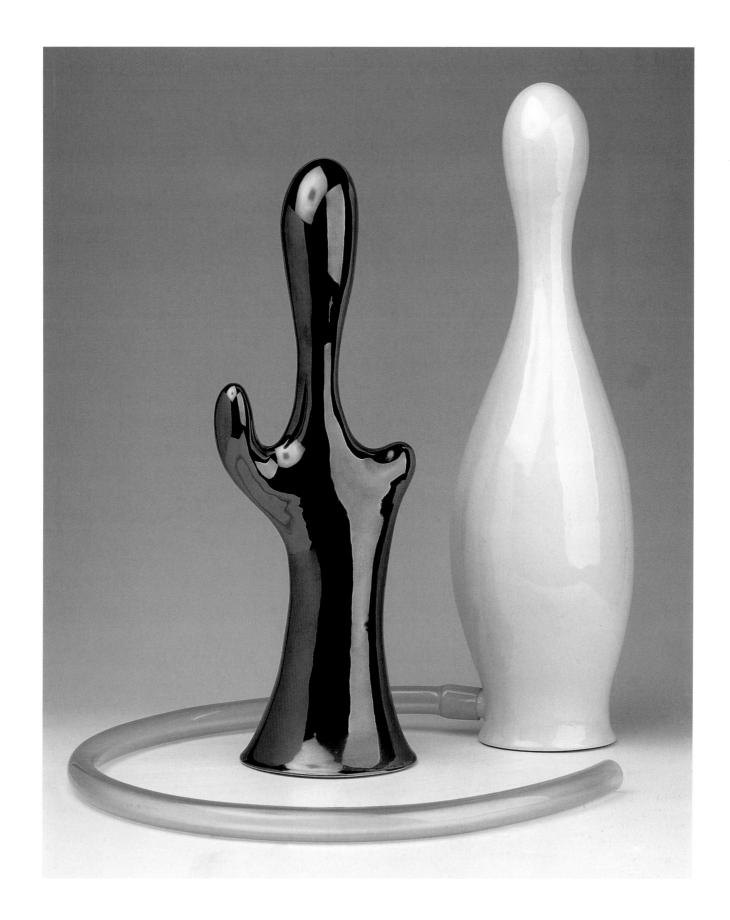

108 **Bunches** 2002
H. 44 cm; 17.5 in
Private collection
Photograph: Philip Sayer

109 **Lamp** 2002
H 48 cm; 19 in
Collection: the Artist
Photograph: Philip Sayer

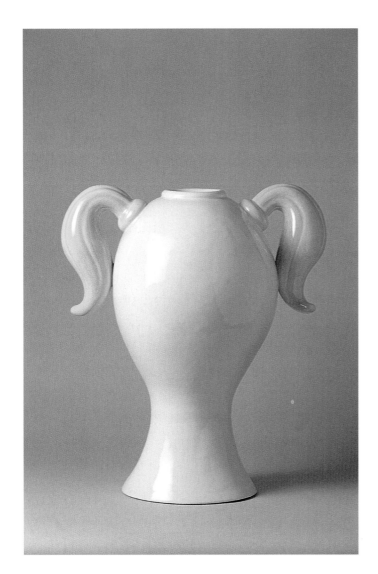

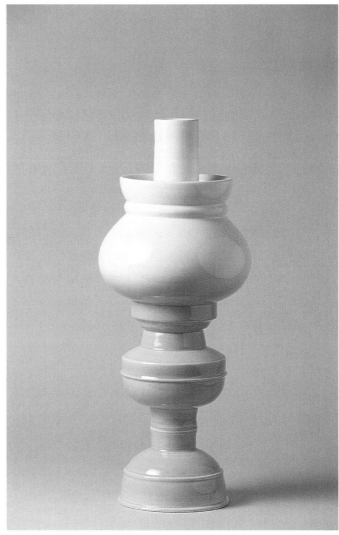

110  **Mad Cow Dish**  2002
W. 30 cm; 11.75 in
Collection: the Artist
Photograph: Philip Sayer

111  **Corinthian Softwhite**  2002
H 61 cm; 24 in
Collection: the Artist
Photograph: Philip Sayer

**Doric Energy Saver**  2002
H. 65 cm; 25.25 in
Collection: the Artist
Photograph: Philip Sayer

**Ionic Spotlight**  2002
H. 63 cm; 24.75 in
Collection: the Artist
Photograph: Philip Sayer

**Tuscan Frosted**  2002
H. 60 cm; 23.5 in
Collection: the Artist
Photograph: Philip Sayer

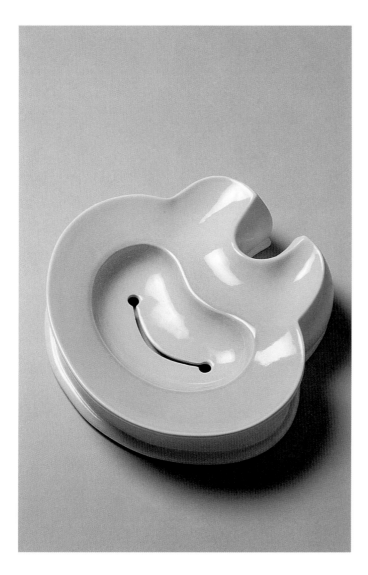

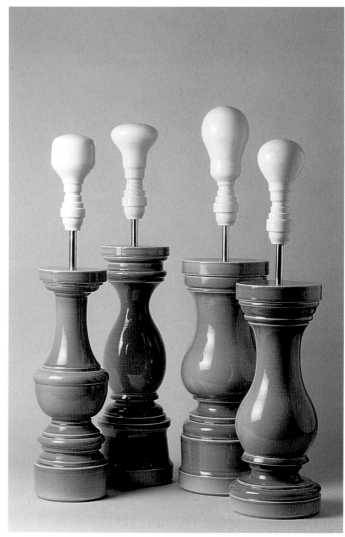

112 **Weather** 2000
   H. 33 cm; 13 in
   Collection: South East Arts Crafts
   Collection, Brighton & Hove Museum
   Photograph: Philip Sayer

113 **Evil One** 2002
   H 48 cm; 19 in
   Private collection
   Photograph: Richard Slee

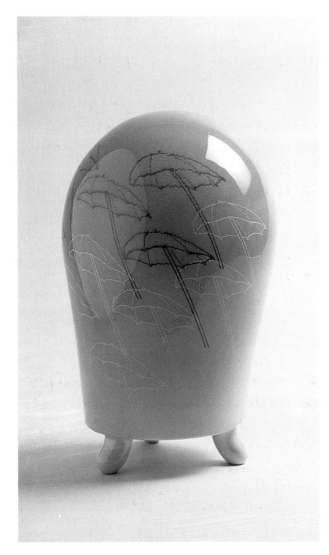

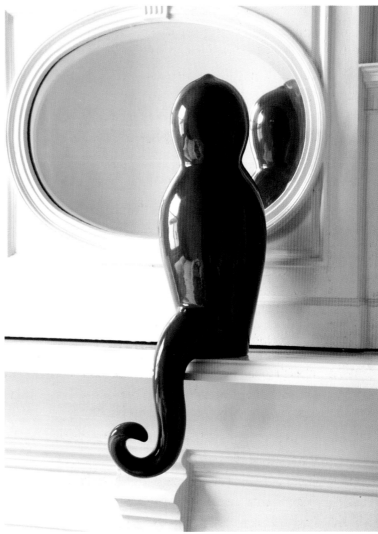

# Chronology

1946   Born Carlisle, Cumbria, England

1964–5   Carlisle College of Art and Design

1965–70   Central School of Art and Design (BA Ceramics, First Class Honours)

1970–1   Designer/technician, Electric Colour Company, London

1971–3   Ceramic technician, Central School of Art and Design

1973   Ceramic design consultant, Mural Project, Macedonia (formerly Yugoslavia)

1973–5   Full-time lecturer, Hastings College of Further Education

1975   Own studio, London

1975–90   Visiting lecturer, Central Saint Martin's College of Art and Design and Brighton Polytechnic, and senior lecturer, Harrow School of Art

1980   Own studio, Brighton

1982   Workshop leader (with Jacqui Poncelet), Ceramic Workcentre, Heusden, The Netherlands

1985–7   External examiner, Camberwell College of Arts, Department of Ceramics

1986   Summer guest artist, Watershed Center for Ceramic Arts, Maine, United States

1986–8   Royal College of Art, London (MA Design, RCA, Degree by Project)

1987–90   External examiner, Loughborough College of Art, Department of Ceramics

1989   Visiting artist, Department of Fine Art, University of Colorado, United States

1989   Workshop leader (with Tjok Dessauvage), World Crafts Council, Belgium

1990   Visiting artist, Banff School of Fine Arts, Alberta, Canada

1990   Senior lecturer, Camberwell College of Arts

1992   Professor of the London Institute

1992   Invited artist, the Third Annual International Clay Arts Camp, Korea

1995–8   Course director, Ceramics, Camberwell College of Arts

1996   Resident artist, Highland Print Makers, Inverness, Scotland

1997   Invited artist, JICA, Hongik University, Korea

1998   Curator, *Off the Wall, On the Floor*, The London Institute Gallery, London

1998–02   External examiner, Glasgow School of Art, Department of Ceramics

1998–   Principal lecturer, Camberwell College of Arts

2000   Sculpture commission for *Sculpture at Goodwood*

2000   Co-curator, *Futuremap 2000*, The London Institute Gallery, London

2000–   Member of the Crafts Council Setting-up Grants Committee

2001   Invited workshop artist, *World Ceramic Exposition*, Ichon, Korea

2002   Curator, *Sleepers: Ceramica*, Royal Cornwall Museum, Truro, Cornwall

2003   Visiting artist, Monash University, Melbourne, Australia

# Selected exhibitions

## Solo exhibitions

**1977** *Richard Slee*, Smith + Others Gallery, London

**1983** *Richard Slee*, Crafts Council Shop, Victoria and Albert Museum, London

**1985** *Richard Slee*, Gallerie Het Kapelhuis, The Netherlands

**1986** *Richard Slee*, Crafts Council Shop, Victoria and Albert Museum, London

**1987** *Richard Slee*, Hordaland Kunstersentrum, Bergen, Norway and Gallery F.15, Oslo, Norway

**1989** *Richard Slee*, City Gallery, Leicester (catalogue)

**1990** *Richard Slee*, National Museum, Stockholm, Sweden

**1991** *Richard Slee*, Aberystwyth Arts Centre, University of Wales (catalogue)

**1994** *Richard Slee*, Hering and Lehmann Gallery, Berlin, Germany

**1994** *Richard Slee*, Garth Clark Gallery, New York

**1996** *Richard Slee*, Studio Pottery Gallery, Exeter, Devon

**1998** *Richard Slee*, Barrett Marsden Gallery, London (catalogue)

**2000** *Richard Slee*, Barrett Marsden Gallery, London (catalogue)

**2002** *Richard Slee: A Take on Toby Jugs*, Glynn Vivian Art Gallery, Swansea, Wales

**2002** *Richard Slee*, Barrett Marsden Gallery, London

**2002** *Richard Slee*, The Scottish Gallery, Edinburgh, Scotland

**2003** *Panorama*, Tate St Ives and Ruthin Crafts Centre (catalogue)

**2003** *Show5* – Richard Slee, Retrospective, The Potteries Museum & Art Gallery, Stoke-on-Trent

## Group exhibitions

**1981** *British 20th Century Studio Ceramics*, Christopher Wood Gallery, London (catalogue)

**1981** *British Ceramics and Textiles*, Knokke Heist, Belgium, British Council (catalogue)

**1982** *Exhibition 1*, Aspects Gallery, London

**1982** *Nonconformists?*, Gallerie Het Kapelhuis, The Netherlands

**1983** *Fifty Five Pots*, The Orchard Gallery, Londonderry, Northern Ireland (catalogue)

**1984** *Richard Slee/Katherine Virgils*, British Crafts Centre, London (catalogue)

**1984** *Three Generations of British Ceramics*, Maya Behn Gallery, Zürich, Switzerland

**1984** *English Ceramics*, Charlotte Hennig Gallery, Worms, Germany

**1985** *British Ceramics*, Museum Het Kruithuis, The Netherlands (catalogue)

1985 *Fast Foreword*, Institute of Contemporary Art, London and Kettles Yard, Cambridge (catalogue)

1986 *British Ceramics*, Dorothy Wiess Gallery, San Francisco, United States

1986 *Made in Britain*, Kunsthandwerk, Berlin, Germany (catalogue)

1986 *Britain in Vienna*, Kunstlerhuis, Vienna, Austria, Central Office of Information (catalogue)

1986 *English Ceramics 1980–1986*, Kunstformen Jetzt, Salzburg, Austria

1987 *English Ceramic in Bassano*, Bassano del Grappa, Italy (catalogue)

1987 *Our Domestic Landscape*, Cornerhouse Gallery, Manchester and UK tour (catalogue)

1988 *East-West Contemporary Ceramics*, Seoul, Korea and Hong Kong, British Council (catalogue)

1988 *Contemporary British Crafts*, National Museum of Modern Art, Kyoto and Tokyo, British Council (catalogue)

1989 *Richard Meitner, Richard Slee, Martin Smith, Eko Yoshika*, Gallerie Het Kapelhuis, The Netherlands

1990 *Three Ways of Seeing*, Crafts Council, London and UK tour (retrospective)

1990 *British Design*, Tokyo, Japan (British Council)

1990 *Contemporary British Crafts*, Mitharado Gallery, Tokyo, Japan

1991 *Colours of the Earth*, India and Malaysia tour, British Council (catalogue)

1991 *Contemporary Work in Ceramics*, Brighton Polytechnic Gallery (catalogue)

1992 *Aspects of Sculpture*, Marianne Heller Gallery and German tour

1992 *Arts and Crafts to the Avant-garde*, Royal Festival Hall, London

1993 *Anticipation*, Stedelijk Museum of Modern Art, Amsterdam, The Netherlands

1993 *Visions of Craft*, Crafts Council, London (catalogue)

1993 *The Raw and the Cooked*, Museum of Modern Art, Oxford, and touring London, Oxford, Swansea, Japan, Taiwan and France (catalogue)

1993 *Against Nature*, Sight Specific, Arundel, Sussex (solo with guest Robert Dawson)

1995 *Out of this World*, Crafts Council, London and UK tour

1996 *Transformations: The Integration of Computers, Print Technology and Printmaking*, The London Institute Gallery, London, Brisbane City Art Gallery, Australia and Australian tour (catalogue)

1996 *Hot off the Press*, Tullie House Museum, Carlisle and UK tour (catalogue)

1996 *Jerwood Prize for the Applied Arts*, Crafts Council, London and Germany tour (catalogue)

1996 Contemporary British Ceramics, National Museum Ljubljana, Slovenia (catalogue)

1997 *Richard Slee/Lah Weston*, Claude Andre Gallery, Brussels, Belgium

**1997** *Kaleidoscope*, Contemporary Ceramics, London

**1997** *Fletcher Challenge*, New Zealand, Merit Award winner (catalogue)

**1997** *A Grand Design: The Art of the Victoria and Albert Museum*, Baltimore Museum of Art and US tour (catalogue)

**1997** *Glazed Ceramics*, Contemporary Applied Arts, London

**1997** *JICA*, Seoul Centre Gallery, Korea (catalogue)

**1997** *Transformations*, Oriel Gallery, Cardiff, Wales

**1997** *Body Language*, Newport Museum and Art Gallery (catalogue)

**1998** *Applied Art into Print*, Highland Print Makers Gallery, Gainsborough House, Suffolk and tour

**1998** *A View of Clay*, Contemporary Applied Arts, London

**1998** *Atlantic Crossings*, Barbican Centre, London

**1999** *The Plate Show*, Collins Gallery, University of Strathclyde, Glasgow and UK tour (catalogue)

**2000** *Steninge International Ceramic Exhibition*, Steninge Slott Kulturcenter, Sweden (catalogue)

**2000** *Value Judgements*, curated by Northern Lights, touring Cleveland Crafts Centre, Middlesbrough; Bluecoat Display Centre, Liverpool; Ruskin Gallery, Sheffield

**2000** *Firing Imagination: Ceramica Britannica*, Centro Brasileiro-Britanico, São Paulo, Brazil and Salvador, British Council (catalogue)

**2000** *Get Real: Romanticism and the New Landscape in Art*, ArtSway, Sway, Hampshire and UK tour (catalogue)

**2000** *Contemporary English Ceramics*, Keramikmuseet Grimmerhus, Denmark (catalogue)

**2000** *A Sense of Occasion*, Crafts Space touring and MAC Birmingham and UK tour (catalogue)

**2001** *A Public Auction of Private Art Works*, Kimbolton Castle, Cambridgeshire, curated by Nina Pope (catalogue)

**2001** *The Illuminated Calvino*, Conningsbury Gallery, London (catalogue)

**2001** *Jerwood Applied Arts Prize*, award winner, Crafts Council, London and UK tour (catalogue)

**2001** *Thirteen Hands*, West Highland Museum, Fort William, Scotland and tour (catalogue)

**2002** *Sleepers*, Royal Cornwall Museum, Truro

**2002** *The Uncanny Room*, Pittshanger Manor, Ealing and Bowes Museum, County Durham (catalogue)

**2003** *Flowerpower*, Norwich Castle Museum and UK tour (catalogue)

**2003** *Hypercrafting*, Monash University, Melbourne, Australia (catalogue)

**2003** *Good Bad Taste*, Keith Talent Gallery, London

# Collections

**Australia**
Monash University

**Belgium**
Knokke Heist Municipality

**Japan**
Museum of Modern Art, Kyoto
Shigararaki Ceramic Cultural Park

**The Netherlands**
Museum Het Kruithuis
Stedelijk Museum, Amsterdam

**Slovenia**
Muzej GRAD

**Sweden**
National Museum, Stockholm

**United Kingdom**
Arts Review, London
Bradford City Museum
British Council
Buckinghamshire County Museum
Crafts Council, London
Hove Museum, South East Arts Collection
James Mayor Gallery, London
Leicester City Museum

Norwich Art Gallery
Paisley Museum, Scotland
The Potteries Museum & Art Galley, Stoke-on-Trent
University College of Wales
Victoria and Albert Museum, London

**United States**
Los Angeles County Museum

# Selected bibliography

124

Berry, John, 'Richard Slee: Craft potter', *Ceramic Review*, September 1990

*British Ceramics*, exh.cat., essay by Ed Allington, Museum Het Kruithuis, The Netherlands, 1985

Britton, Alison, 'Sèvres with Krazy Kat', *Crafts*, May 1983

Britton, Alison, 'Glazed ceramics', *Crafts*, November 1997

Clark, Garth, *The Potter's Art: A Complete History of Pottery in Britain*, Phaidon, London, 1995

Courtney, Cathy, 'Book plates', *Art Monthly*, December 1995

Deacon, Richard, *Richard Slee/Katherine Virgils*, exh.cat., British Crafts Centre, London, 1984

Del Vecchio, Mark, *Postmodern Ceramics*, Thames and Hudson, London, 2001

de Waal, Edmund, 'Something nasty in the suburbs', *Crafts*, November 1998

Dewald, Gabi, 'Gübe Von Hieronymus', *Keramic Magazine*, November 1994

Dewald, Gabi, 'Keramishe plastik', *Neue Bildende Kunst*, February 1995

Dormer, Peter, 'Routes of exchange', *Crafts*, May 1984

Graves, Ann, 'Slee selects', *Ceramic Review*, September/October 2002

Greenhalgh, Paul, 'Richard Slee', *Studio Pottery*, February 1993

Harrod, Tanya, 'Afterword', *Crafts*, January 2000

Harrod, Tanya, 'The nature of the beast', *Ceramic Review*, September/October 2001

Harrod, Tanya, *The Crafts in Britain in the 20th Century*, Yale University Press, New Haven and London, 1999

Haslam, Malcolm, 'Richard Slee: Review, Barrett Marsden Gallery', *Crafts*, July 2000

Hetterly, Sean, *Richard Slee: Recent Works*, exh.cat., The City Gallery, Leicester, 1989

Houston, John, *Richard Slee: Ceramics in Studio*, Bellew Publishing/Crafts Council, London, 1990

Jackson, Lesley, 'Intense times for an ironic potter', *The Independent*, 6 October 2001

Kim Jong-In, 'Richard Slee', *Arts and Crafts* (Korea), July 1992

Maiden, Emma, 'A career in clay', *AN Magazine*, October 2002

Margrie, Victor, 'Richard Slee: Recent works', *Crafts*, January 1990

Marshal, Aloma, 'Richard Slee's tableware commission', *Ceramics Technical* (Australia), 1998

Perry, Grayson, 'Richard Slee', exh.cat., Barrett Marsden Gallery, London, 2000

Pike, Steve, *Life in Art*, Saga Trust, Sandgate, Kent, 2001

Pitts, Julia, 'Artist: Richard Slee', *Arts Review*, October 2001

Slee, Richard, 'Richard Slee', *Ceramic Review*, January 1983

Slee, Richard, 'Reinventing the familiar', *Artist Newsletter*, June 1995

Street-Porter, Janet, 'Slee notes', *Design*, no.293, May 1973

Vincent, Paul, 'Richard Slee in New York', *Studio Pottery*, April 1994

Vincent, Paul, 'Slee crowned king', *Ceramics in Society*, Autumn 2001

Vincent, Paul, 'Slee is king', *Studio Pottery*, June 2000

Vivas, Antonio, 'Richard Slee, o el Arte de Imprimir', *Internacional Cerámica*, Madrid, no.66, 1998

Watson, Oliver, *Richard Slee: Grand Wizard of Studio Ceramics*, exh.cat., Barrett Marsden Gallery, London, October 1998

Watson, Oliver, *Richard Slee, Grand Wizard*, exh.cat., Tate St Ives, 2003

Wilson, Michael, 'Richard Slee: Barrett Marsden Gallery', *Ceramic Review*, May 2000

# Acknowledgements

The Artist would like to thank the following for their contribution and help in making this major survey of his career possible: the writers Cathy Courtney and Garth Clark for their intellectual insight and patience in the production of the main essays; Louise Taylor for her Foreword; the photographers, with special mention to Zul Mukida and Phil Sayer for their empathy and vision; Chrissie Charlton for her exemplary design skills; Simon Perry for his organisational professionalism; and of course those unknown to me that have made the production of this project possible.

This book and the accompanying retrospective exhibition would not have been possible without the generosity of the collectors who have lent work for both photography and for exhibition.

My thanks also for the moral support received from Barrett Marsden Gallery and also to colleagues at Camberwell College of Arts, especially those within ceramics. I am also grateful for the research support provided by The London Institute.

Finally to Linda and Pearl – they know who they are.

**Richard Slee**
Brighton, 2003

# Index of works